To John Mr., with all
best wishes from the author

Henry Trunk
Oct. 1971

THE PICTURE BOOK OF BRASSES IN GILT

The Picture Book
of Brasses in Gilt

HENRY TRIVICK

With 242 illustrations in gilt and black

5 ROYAL OPERA ARCADE PALL MALL LONDON SW1

© 1971 HENRY TRIVICK

Published in 1971 by
JOHN BAKER (PUBLISHERS) LTD
5 Royal Opera Arcade
Pall Mall, London SW1

ISBN 0 212 98382 2

Printed in Great Britain by
W & J MACKAY & CO LTD, CHATHAM

Contents

Acknowledgements

This book is intended as a successor or a complement to *The Craft and Design of Monumental Brasses* published in 1969. It is not a cheaper version of this book since it contains much new material.

I owe a considerable debt to the incumbents of the many parish churches who have so kindly given me permission to make rubbings off the brasses. Over two thirds of the illustrations are taken from my own rubbings.

To the following I wish to tender my thanks for permission to reproduce photographs.

Asah Shimbun, Tokyo. The Nara Museum. The British Museum. The Victoria & Albert Museum. The Society of Antiquaries. The County Museum, Aylesbury. The Luton Museum. The Reading Museum & Art Gallery. The Berkshire Archaeological Society. The National Monuments Record. Dr A. Elliott, Mr C. N. Gowing, Mr R. Miles and Mr F. M. Underhill. Institut für Denkmalpflege Arbeitsstelle, Halle. The Dean & Chapter, St Paul's Cathedral. The AKKO Municipal Museum, Israel.

For very kind assistance in many ways when writing this volume I owe a debt to the following and wish to record my thanks.

Mr K. B. Gardner, Keeper, Dept of Oriental Books and Manuscripts, and Mr J. K. Rowlands, Assistant Keeper, Dept of Prints and Drawings, The British Museum. Mr R. W. Lightbown, Assistant Keeper, Dept of Metalwork, The Victoria & Albert Museum. Mr Vesey Norman, Assistant to The Director, The Wallace Collection. Mr A. B. R. Fairclough, The Council for The Care of Churches. The British Museum Library. The Victoria & Albert Museum Library. Marlow Library. The Ashmolean, Oxford. The Courtauld Institute. The Warburg Institute. Mr John Coales, Hon Secretary, Monumental Brass Society. The Very Rev. The Dean, Durham Cathedral. St. Albans. Mr C. Gowing, County Museum, Aylesbury. Mr T. L. Gwatkin, Reading Museum & Art Gallery. Mr Peter Smith, Luton Museum. Mr F. M. Underhill, Berkshire Archaeological Society. The Rev S. Doran, Vicar, Bray, Berks. Miss Cicely Tower. Miss Meriel Tower. Mrs M. Gaskell for typing my manuscript and Mrs Thomas, writing from France, for giving me information on French brasses and slabs. I wish to thank Mr John Baker my publisher for making valuable suggestions and for showing great patience and understanding of my many requests and to Mr Kidd for assisting in the production of this volume.

Illustrations

Numbers in italic refer to Figures

Introduction

The reproductions in this volume, in a black and gilt colour, are largely taken from 'off the top of the brass' originals. This ensures an authentic reproduction of the original design as conceived by the medieval craftsman. There is no doubt whatsoever that the 'positive' gilt and black reproduction is the correct method of reading a brass.

These reproductions reveal several features of design that cannot be read properly by the negative black and white rubbing. In particular the expressions and features of the effigies become an accurate representation when seen as positives, revealing the true character of the individual. This means that there are more portraits on brasses than is usually credited.

A good number of English brasses are considerable works of art, mainly those of the fourteenth century. The design of some of these is so excellent and refined that they surpass the widely acclaimed, large, quadrangular Continental brasses. These are magnificent for their craftsmanship but are uninspired and mechanical and have little aesthetic quality.

The illustrations in this volume represent only a small selection of the many thousands available. They have been selected for some particular feature of interest.

In the study of the monumental brass it is necessary to include social and trading conditions between this country and the Continent. The interchange of artistic ideas and problems is of paramount importance as is also in the more intimate study of the stone and wooden sculptural effigy, the incised stone slab effigy, brass and copper effigies, embroidery, coloured glass windows, mosaics, murals, enamels, illuminated manuscripts, paintings, drawings and engravings.

All these arts and crafts had basic roots which were fed by social and religious tendencies of the time.

These arts and crafts were the handmaidens of ecclesiastical architecture. No genuine artist or craftsman can escape the influences and conditions of his time, so all medieval artists and craftsmen were, in one way or another, subjected to the power wrought by the great architectural building of cathedrals and churches in this country and abroad. The best brasses were inspired by this tradition. The later brasses, those of the sixteenth and seventeenth centuries, were often produced by a band of inferior craftsmen eager to meet a demand from almost all classes, rich or poor. They often put unnecessary detail in the memorials in order to obtain a higher fee. The result was the production of a mass of derivative brasses with only slight variations.

In the eighteenth, nineteenth and twentieth centuries a number of brasses were produced – these are largely inscription plates but there are a small number of effigies and interesting devices, some of considerable merit and skill, that deserve the attention of the brass enthusiast. A few appear in this book.

The distribution of brasses makes an interesting study; Oxfordshire, Kent, Norfolk, Bucks., Surrey, Herts., Beds., Berks., Essex and Middlesex are the ten most *densely* distributed counties for brass memorials, with Norfolk containing the greatest number. Wales has between fifty and sixty, Scotland six, and Ireland five (see page 31).

The counties with the most *wealthy* people and with the more desirable centres in which to live, both by reason of livelihood, position and convenience, became more densely populated. Those counties with stone quarries or nearby stone quarries, were supplied with incised stone slabs and so there was little demand for the brass incised plate.

Brasses are important records of our ancestors – most are named and dated. They have preserved for us not only the names of some illustrious people but also the names of many humble ones, about whom if it were not for the brass inscriptions, we should know nothing. Nobility, ecclesiastics, knights and their ladies and children, merchants, parish priests, monks, tradesmen, students, lawyers, notaries, and others are all

recorded on brass. Their armour, costume, head-dress, vestments, coats of arms and other accessories are often displayed on the brass. They show a true picture of a cross-section of the medieval people of our land.

Most effigies are depicted with their hands together, as in prayer. Some few brasses show the hands spread outwards – an East Anglian characteristic (figs. 119, 143). The effigies are not standing, but lying on their backs, though many brasses show the figures on little hillocks with flowers or with animals at their feet. The heads

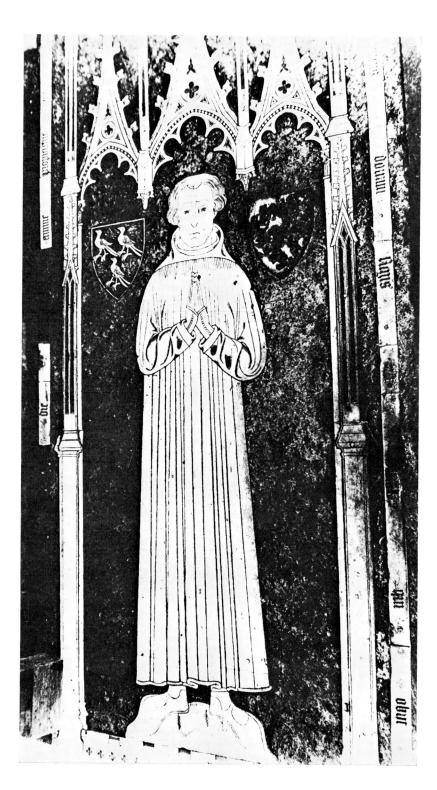

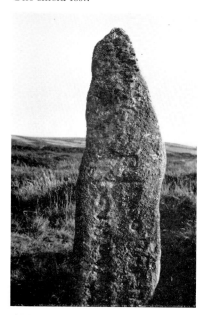

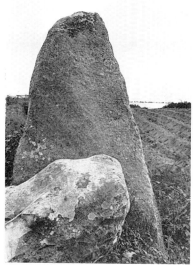

A. (*left*) John Rede, 1404, Checkendon, Oxon. A civilian under triple canopy and marginal inscription (defaced). One shield lost.

B. (*upper*) Mên Scryfa, Madron, Cornwall. Monument with inscription Rialobrani Cunovali fili *of Rialobranus son of Cunovalus*. (*The monument of* may have been understood.) Fifth or sixth century A.D. (*lower*) Menhir de la Boutinardière, Lower Loire, France. There are several thousands of similar menhirs in France, usually placed in line formation. Most of these are rough pillars of stone up to 10–12 ft. high with their bases fixed into the earth.

of ladies often rest on cushions, even when the figures are standing (figs. 17, 48, 119, 127, 138, 157, 191, 203, 204, 207 and maps).

Brasses vary greatly in shape and size – from life-size to a few inches.

It would be appropriate here to clarify the correct terminology in connection with the brass memorial.

The effigies, inscriptions, shields, coats of arms, canopies, merchants' marks, and guild badges are engraved on flat sheets of plates of brass. These are set into the stone or marble slab which is known as the casement.

The countersunk design which has been cut to receive the engraved or incised brass is known as the indent or matrix. The brass plates are usually held in position by pitch and special rivets or pins. The brass of John Rede (fig. A) shows the brass and accessories in their casement.

1 · *Early memorials*

From early times man has desired to perpetuate the memory of his kindred whom he loved and respected, after they passed away. Early man placed a heap of stones (a cairn) around his dead; then large erect stones (menhirs or cromlechs). The Celts buried their dead by throwing a mass of earth over the bodies, and many personal belongings were buried with them. Weapons, urns, beads, torques, and other items have been found in ancient burial grounds of the early Anglo-Saxons, who at first followed somewhat the same burial method as the Celts. Later were erected elaborate gravestones and tombs. In the Middle Ages there were altar tombs with effigies of great beauty and skill placed under splendid canopies.

Mausoleums were built to accommodate the various members of wealthy and important families when they passed away.

Early Christian gravestones were of three kinds:

(1) Flat stones with or without an incised cross or symbol

(2) The raised cross slab – coped, with a low relief cross or symbol

(3) Headstone crosses – with symbols incised or in relief placed at the head of the grave (fig. C).

The Romans used gravestones inscribed with the name and trade or profession of the deceased. They also used a sarcophagus, a hollowed-out stone coffin in which to place the dead. The sides were cut with numerous figures, symbols, decorations and inscriptions. A cross was displayed on the lid of some of the sarcophagi. Examples can be seen in the Lateran Palace in Rome (fig. D).

Due to the influence of the Romans throughout the Christian world the cross on top of the tomb became a common feature on gravestones. By the third or fourth

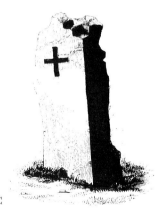

C

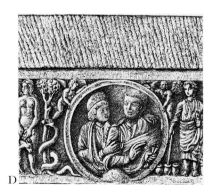

D

C. Standing memorial headstone of St Monachan, near Dingle, Ireland, fifth century.

D. Detail from fourth-century sarcophagus found under the floor of St Paul's Church on the Ostian Way, Italy. Now in Latern Palace.

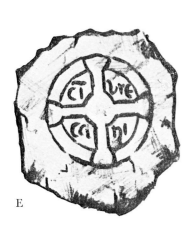

E

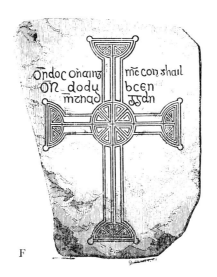

F

E. Fragment of stone of St Brecan, Isle of Arran, Ireland, A.D. 500. Discovered in the early nineteenth century on the side of his tomb.

F. Incised cross slab, Clonvachoise, Ireland, A.D. 822. Translated the first line reads *A prayer for Conaing son of Cougal*. The second and third lines read *A prayer for Dulcen son of Thadggan*. The characters are similar to those used in Irish MSS. of the period.

G. (*below*) A thirteenth-century coped coffin lid of wood with cross, Winterbourne Church, Berks.

centuries the sarcophagi became more elaborately decorated with sculptural carvings; a few of these remain in Italian cities, as well as in Spain, France, and in a few other locations in Europe.

The earliest cross slabs of the British Isles are found in Ireland, dating from the sixth and ninth centuries (figs. E and F). In England examples date from the ninth century. Sometimes sarcophagi lined with lead were used as well as wooden coffins. Often a hole was dug, the body laid in it and simple stone or wood cover placed on top (fig. G). Fig. H shows an elaborate coped stone lid of the tenth century.

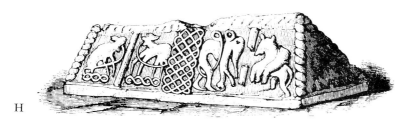

H

H. Small coped coffin lid, Anglo-Saxon, early tenth century, Bakewell Church, Derbyshire.

An important early coped stone coffin is that of William Rufus in Winchester Cathedral, dated 1100 (fig. J). Fig. K is a memorial stone slab to his sister who died in 1086. Fig. L shows an excellent raised cross slab with inscription *c.* 1150. Another interesting stone coffin is that of Llewelyn, Prince of Wales, dated 1240, in the church at Llanrwst. It is decorated with a simple quatrefoil motif (fig. M).

Double stone coffins for husband and wife, and brother and sister or their kindred, made their appearance about the twelfth century. The lids were decorated and always included a cross but no effigy (fig. N).

The thirteenth century saw a development of the coffin lid. A head appeared on the top above the cross and presumably this was intended to be a portrait of the deceased (fig. O).

Variations of this type of monument occur frequently. The cross was omitted and only the head and feet shown. In the space between these features were placed heraldic symbols and accessories (fig. P).

Many of these coffin lids were tapered. The *complete* effigy of the deceased first appeared in low relief on the stone lid about the eleventh century. Some of these are

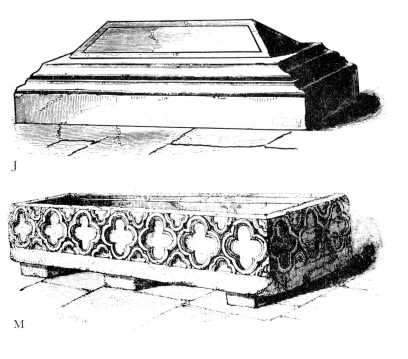

J

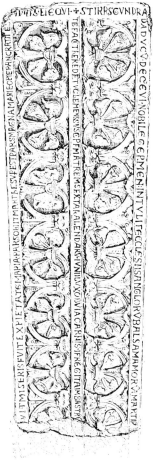

K

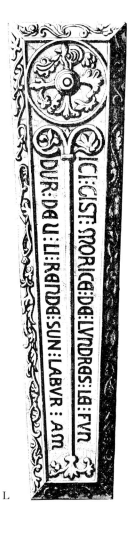

L

M

N

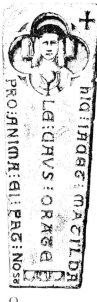

O

J. The simple tomb of William Rufus, Winchester Cathedral, 1100. It is remarkable that this coffin of William II is entirely without decoration. Not only is it coped but the ends of the top are sloping.

K. Black marble slab memorial to Princess Gundrada, wife of William, Earl of Warenne, and fifth daughter of William I. She died in 1086, but the memorial slab is about 1250. Now in the church of St John the Baptist, Lewes, Sussex. The coffin was found in the ruins of the priory adjoining the church in the early nineteenth century.

L. Raised cross slab to Maurice de Londres, Ewenny, Glam., *c.* 1150. A fine example.

M. The coffin of Llewelyn, Prince of Wales, Llanrwst Church, 1240. It was removed from Conway in the time of the Dissolution of the Monasteries to its present site.

N. Twelfth-century double slab at Aycliffe, County Durham; possibly to brothers. On the left a wool merchant, on the right an armourer. Another suggestion is that it is a memorial to a wife (left) and husband (right).

O. Transitional type of memorial stone slab showing head and feet of Matilda le Caus. The centre line inscription is designed to take the place of the stem of the cross. Brampton Church, Derbyshire, early fourteenth century.

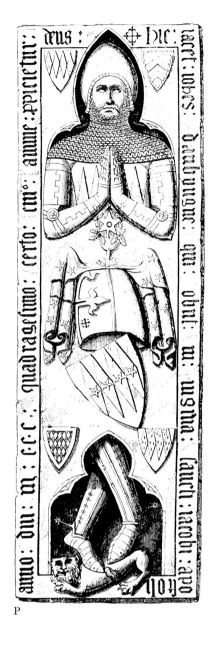

P

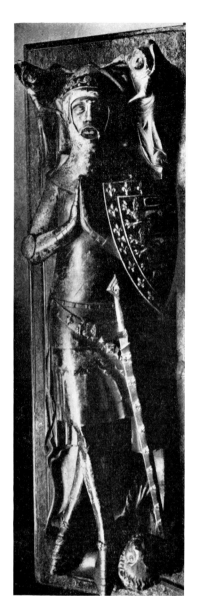

Q

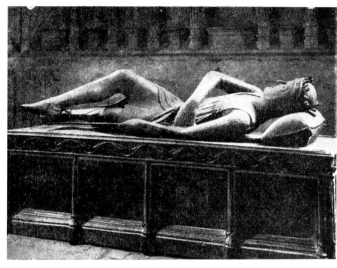

R

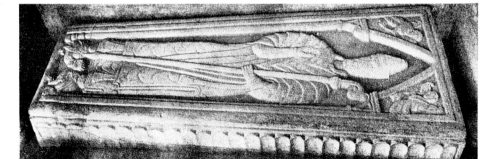

S

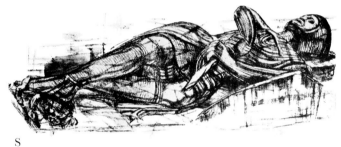

T

P. Sir John Daubygne, 1346, Brize Norton, Oxon. A later development of fig. 12. The cross no longer appears. The knight's legs are crossed and he stands upon a lion.

Q. Lord John of Eltham, *c*. 1340, Westminster Abbey. Similar to contemporary brasses. He is on an altar tomb. The canopy, destroyed in 1760, consisted of three tall gables with vaulting, the central gable rising higher and the finials as angles.

R. Robert Courthose, Duke of Normandy, 1290, Gloucester Cathedral.

S. Crusader knight, *c*. 1300, Dorchester, Oxon.

T. Bartholomew Iscarnus, Bishop, Exeter Cathedral, *c*. 1180. In purbeck marble.

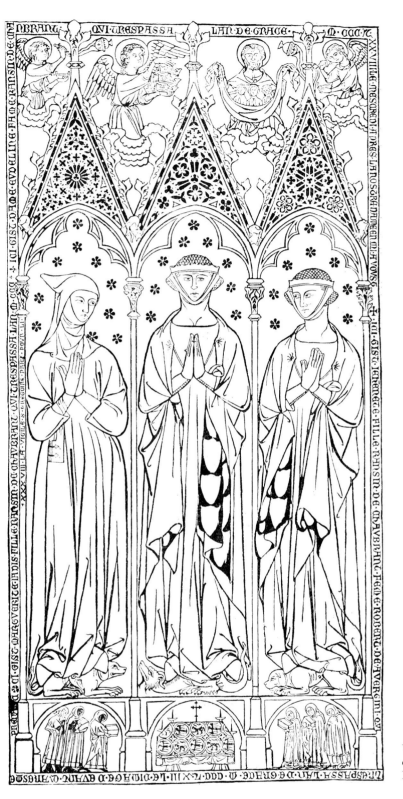

V. Fifteenth-century incised cross slab with incised figures, an unusual combination. Christ Church near Caerleon, Brecknockshire. There was a superstitious custom in the neighbourhood that sick children laid on this stone on the eve of Ascension Day would be cured.

U. Eudeline Chaubrant and her daughters, 1338, Chârlons sur Marne, France. Incised stone slab.

very beautiful and have an aesthetic quality peculiar to the period. It was a quality of great faith that produced such fine carvings. Examples are Vitalis, 1082 (Westminster Abbey), Gilbertus Crispinas, 1117 (Peterborough) and Bishop Bartholomew Iscarnus, 1180 (Exeter Cathedral) (fig. T).

Heraldic display made its appearance on tombs and canopies and this became an extravagant fashion in succeeding centuries.

2 · *Three-dimensional effigies as part of a memorial tomb*

These first made their appearance in England in the thirteenth century (about two centuries later than on the Continent). The art of figure carving came from a great tradition of several centuries. Saxon, Romanesque and Gothic carvers had all produced a great variety and quantity of religious works that were part of the architectural movement of the time. In this country English builders of cathedrals and churches led the way. These builders were the most inspired in Europe for approximately 150 years (from about 1150).

The English tomb carvers were individual and brilliant craftsmen as befits a great English tradition. The list and variety of sculptural effigies for the next three centuries is quite considerable. Many are an integral part of elaborate canopy tombs (fig. Q).

Materials were various: purbeck marble, stone, alabaster, freestone, bronze, copper, brass, wood, terracotta, sandstone and other media. In Worcester Cathedral there is a fine coloured effigy of King John, 1240. The coloured effigy of Robert Courthose, Duke of Normandy, 1290, in Gloucester Cathedral is an example of great simplicity of woodcarving, but lacks nothing on this account (fig. R). At Dorchester Abbey, Oxon., there is a fine spirited alabaster carving of a crossed-legged knight, *c.* 1300, of the Abingdon workshops (fig. S).

The list of truly important three-dimensional tombs with or without canopies and accessories could be extensive. Anyone visiting a few of our cathedrals and parish churches would soon find examples of the great period of English craftsmanship in tomb-making.

Westminster Abbey contains some of the finest tomb effigies ever made in this country.

Alongside this period of sculptural tomb-making there appeared the *incised* stone slab with effigy. In Creeney's volume of Continental incised stone effigies the *earliest illustrated* is 1150; but this is not the earliest, which belongs to the eleventh century. A fine French example of the fourteenth century is illustrated (fig. U). The earliest English incised stone effigy is 1150.

The incised stone slab had a great advantage over the canopy effigy tomb; it took up far less space than the three-dimensional recumbent knight and his lady, and could be laid on the church floor or on top of the altar tomb.

It would be wrong to state that the incised stone effigy or the incised brass effigy were developments from the three-dimensional stone or metal effigies. This was not a development – they were additional mediums that answered a demand for the economy of space and money. France, Germany and Italy had produced great artist craftsmen in these media. Gislebertus, the twelfth century genius who created the most remarkable carvings for the church of St Lazarus at Autun and for the church of St Madeleine at Vezelay, must rank with the greatest sculptors of all time. The carvings at Chartres of the thirteenth century, and the series of tombs of the French kings at St Denis, Paris, are magnificent examples of figure tomb carvings of the fourteenth, fifteenth and sixteenth centuries.

The incised stone slab with effigy, many, many thousands of which were made on the Continent, was to last as a form of memorial for several centuries. However, due to

its lack of durability as well as through iconoclasm, the number existing today is comparatively small – only a relative few remain. The number in this country can be counted in hundreds. (Fig. V illustrates a fifteenth century incised stone slab with effigies.) Most of the European countries still retain a number of twelfth- to sixteenth-century headstone slabs (see fig. W). Fig. X illustrates a fragment of an incised slab from the Holy Land.

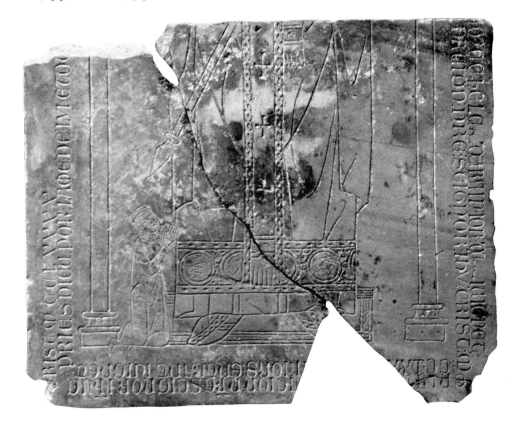

W. Low headstone, Tackley, Oxon, late fourteenth century.

3 · The history of brass

The ancients were acquainted with the alloy of zinc and copper (which we term brass). They were not aware that it contained any other metals. Aristotle in the fourth century B.C. mentioned brass under the name of Mossinolcian copper, which he described as bright and light-coloured, not containing tin but having been melted with a special earth found on the shores of the Black Sea. A genuine Greek coin of Trajan struck in Caria A.D. 110 when analysed was found to contain:

$$
\begin{array}{ll}
\text{Copper} & 77\cdot590 \text{ per cent} \\
\text{Zinc} & 20\cdot700 \\
\text{Tin} & 0\cdot386 \\
\text{Iron} & 0\cdot273 \\
\hline
& 98\cdot949 \\
\text{Impurities} & 1\cdot051 \\
\end{array}
$$

Pliny knew brass under the name of Cadmia. The composition of brass varies. Modern brass contains about 60 per cent copper, 30 per cent zinc, 10 per cent lead or tin. Sixteenth-century monumental brass has been listed as 64 per cent copper, 29 per cent zinc, 4 per cent tin, 3 per cent lead.

X. Fragment of base of incised slab, Acre, Holy Land, 1290. Two line inscriptions in old French.

19

Theophilus, a German monk of the eleventh century wrote a book *Diversarum Artium Schedula*. It was in three parts. The first was on making paints and on painting. The second on the making of coloured glass and glass designing, and the third on various metals and their fabrication. Theophilus describes the making of coarse brass in detail. It was called latten, or latyn, or laton, and at times cullen plate – from Cologne in Germany, where it was manufactured. It was not understood that zinc was a separate metal until about the end of the fifteenth century.

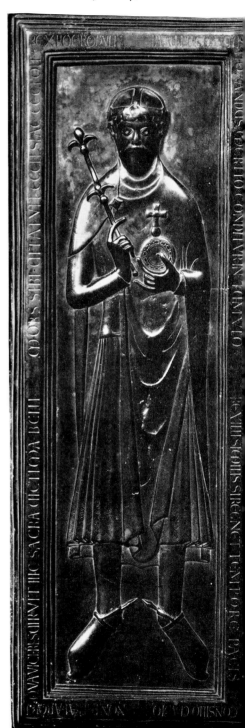

Y. Recumbent figure in low relief of Rudolph of Swabia, 1080, Merseberg Cathedral, Saxony.

This was discovered by the Germans, who melted together copper and calamine ore (zinc carbonate) in fire-resistant containers. Copper deposits were found in northern Germany as well as calamine and used charcoal in the smelting process. The charcoal-burners of the German forests are legendary.

When the brass was made it was hammered out into plates of a somewhat uneven thickness, ready for use. Historical facts show that the Germans made brass considerably earlier than the Flemish.

All brass used in England up to the reign of Queen Elizabeth I was imported. The majority of this brass passed through the hands of the German Hanseatic League, who controlled the sea trade between England and the northern European ports from the Baltic to France. Much of the metal was exported from Bruges, where the Hanse had their own warehouses, houses, homes, and church. It is not generally understood that the Hanse exercised immense power and control over the trade of northern European countries. Lübeck was the chief city of the Hanse and only German merchants were permitted to become members.

The Hanse had several warehouses in England. It was not until 1565 that one William Humphrey obtained permission to manufacture brass in England. It was of an inferior nature.

The Germans were the first of the northern countries of Europe to manufacture brass and develop its trade. They had made utensils from the alloy for export in the eleventh and twelfth centuries. It is only to be expected that we find the earliest brass incised inscription and earliest incised brass effigies in Germany.

The earliest known brass inscription exists at Regensberg. It is a gilded brass plate and records the consecration of an altar dated 1189 (fig. 219). Again in Germany, at Verden, Hanover, is the oldest dated (1231) brass plate incised with an effigy of Bishop Yso Von Welpe (fig. 1). At Ashbourne in Derbyshire there is a brass inscription plate dated 1241 (fig. 217). This proves that before the mid-thirteenth century brass was exported by the Germans to England for engraving inscriptions. It would be interesting to know what connection (if any) there was between the Regensberg consecration plate and the Ashbourne consecration plate, with only ten years between them.

The Germans from early times were among the finest metal workers in Europe and this has continued to the present day.

In Merseberg Cathedral, Saxony, there is an early example of German bronze metal casting. It is a low relief effigy of Rudolph of Swabia, 1080. It is the earliest metal tomb in Europe. It is in fine condition enabling one to appreciate the superb craftsmanship of the eleventh century German craftsman (fig. Y). The design is similar to that used on incised stone slabs and incised brass plates with effigies dating from the twelfth century of the former and the thirteenth century of the latter. Surely this effigy of Rudolph was the forerunner of the memorial incised effigy?

4 · *The aesthetics of early monumental brasses*

It has been shown that the Germans produced the two earliest existing brasses, but the production of the incised brass memorial effigy did not show sizeable numbers until the fourteenth century.

England's earliest incised brass is Sir John d'Aubernoun (fig. 4) at Stoke D'Abernon, Surrey, 1277. There is no known brass effigy existing between the Verden one of 1231 and that at Stoke d'Abernon. It is known that others probably did exist between these dates; but they have long since perished. There is a casement at St Paul's, Bedford, 1208. It would appear that the slab did once contain some brass parts. Other thirteenth century casements exist which appear to have held some brass.

Following chronologically the D'Aubernoun effigy is a German brass – Bishop Otto de Brunswick 1279 at Hildesheim (fig. 2). In character the two German brasses are similar, but quite different from the English one.

As early as the late thirteenth century we find the essential difference between the style of designing on the Continent and in England. In the German brasses, indeed in most of the Continental brasses, the whole rectangular shape of the brass plate is engraved with effigy including relevant data and detail such as arms, inscriptions, etc. In the English plates the effigy is cut to shape and the intervening spaces consist of the stone or marble casement with heraldic shields, coats of arms, inscriptions and other accessories let into the casement as separate items of brass. This is a general condition, but there are exceptions.

The fourteenth century was slow in getting under way with producing brass memorial incised effigies in quantity. The 'golden' era of brasses belongs to the three Edwards – Edward I 1272–1307, Edward II 1307–26, and Edward III 1326–77. During Richard II's reign (1377–99) good brasses were produced but they were smaller and lacked the brilliance of the earlier brasses.

The fine series of the early English brasses are unique, they form a small collection of brass masterpieces:

Sir John D'Aubernoun, 1277, Stoke D'Abernon, Surrey Fig 3
Sir Roger de Trumpington, 1289, Trumpington, Cambs. Fig 5
Sir Robert de Bures, 1302, Acton, Suffolk (fig. 6)
Sir Robert de Setvans, 1306, Chartham, Kent (fig. 7)
Sir John and Lady Creke, 1325, Wesley Waterless, Cambs. (fig. 9)
Sir Hugh Hastyngs, 1347, Elsing, Norfolk (fig. 11)
Sir John D'Aubernoun the Younger, 1327, Stoke D'Abernon, Surrey (fig. 4)
Sir William Fitzralph, 1323, Pebmarsh, Essex (fig. 8)
Lady Camoys, 1310, Trotton, Sussex
Lady Cobham, 1320, Cobham, Kent
Lady Northwood, 1330, Minster in Sheppey (fig. 10)
Laurence de St Maur, 1337, Higham Ferrers, Northants. (fig. 158)

These, and a few others not listed, are the finest effigy brasses of all time.

Later fourteenth-century brasses still retained some of the early character, but were smaller and some lacked the vision and simplicity in which the craftsmen of the early brasses excelled. Who were these craftsmen? We do not know – a few writers contend that some of these brasses were French in origin or in influence, but, whoever made them, we can see that they were artist craftsmen of the highest order.

5. The decline

The fifteenth century still retained a good standard of both design and craftsmanship, but towards the end of the century and in the sixteenth century the standards deteriorated. Workshops produced numbers of uninspired brass effigies, the designs became involved and attempts at producing the effect of three-dimensional form by overworked modelling and cross-hatching technique resulted in less satisfactory memorials (figs. 53, 63). A few of the workshops and individual itinerant craftsmen produced a number of good brasses during the two centuries (figs. 137, 141). The series of knights and their ladies during the sixteenth century displaying heraldic jupons, tabards, and mantles, showed great skill in the design and execution of the coats of arms and

accessories – far in advance of the figures themselves, which were often of a poor standard (figs. 121–3).

Wall brasses made their appearance in the sixteenth century. They were usually in the manner of book illustrations from which they derived. They were rectangular plates showing husband and wife facing each other kneeling at a faldstool, with their sons behind the father, the daughters behind the mother. Scrolls, coats of arms and symbols formed part of the design with the inscription placed under the illustration (figs. 130, 211). These were let into a recessed frame in the wall and are consequently often in better condition than floor brasses (fig. Z and fig. 129).

The seventeenth century brasses – not great in number – were of a 'sketch book' character – as though the individual had posed while the artist made a quick sketch and then added a few details later (see figs. 62, 145). Some of these were most pleasing and showed more individual skill and attention than numerous mid-sixteenth century brasses.

About four brasses with effigies appear in the eighteenth century. Some of the nineteenth-century brasses have considerable merit though somewhat derivative. The late nineteenth-century brasses have more originality.

A few twentieth-century brasses seen by the author are of the 1914–18 war memorial type and show little merit. They attempt to copy sculptural war memorial effigies or paintings by second-rate artists executing similar work.

The inscriptions of the nineteenth to twentieth centuries, of which there are thousands, are not of special interest. A few with finely cut lettering, enamelled in colours and well designed are the exception. A few figure effigies exist. The best are those where the designer has kept to the trend of his own period (fig. 236). Some designers have copied the medieval type of design and as one would expect they are not successful memorials (fig. 239).

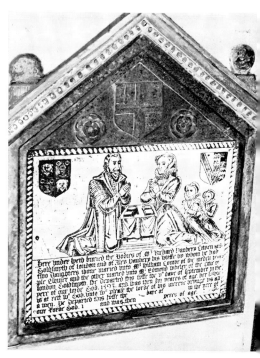

Z. Richard Hanbury and wife Alice, with two daughters, Datchet, Bucks., 1593 (blanks for dates not filled in). One daughter married William Combe of Middle Temple, and the other Edmond Wheller, goldsmith of London.

6 · Schools of brasses

This is a subject where identification of individual schools is largely guesswork unless one is an expert of experts not only of brasses but of artists and craftsmen and their methods. Unless there is sound evidence regarding the productions of the centres or worskhops it is wise to be cautious about attributions. Close similarity of design does not necessarily mean the brasses emanated from the same workshops. Variety in the execution of details, in costume or armour incised in different brasses, does not prove a different craftsman at work. The one craftsman saw the differences in the model or sketchbook and executed brasses with different detail. This is often found in the works of figure painters of the fourteenth to seventeenth centuries.

The craftsman of medieval days was a wanderer, and he moved from place to place executing similar brasses whenever he stopped, to gain reward for his talents. That there were definite fixed centres is certain – London, Oxford, York, East Anglia, Exeter, Gloucester and Hereford were likely centres.

7 · Armour

Brasses are of considerable value to the student of armour in that they depict most of the changes that took place in its appearance over a period of about 350 years – remembering that armour on brasses are line illustrations and brasses do not depict the back of the wearer.

The draughtsman's interpretation of three-dimensional on a flat surface vary according to the individual's technique of translation. This has led to some confusion in the depiction of mail armour and deceived some people into thinking that it was a

different type of mail to the ordinary interlocked mail. So it was named 'banded mail'.

Some of the nomenclature used by writers of the past is wrong. It is advisable to refer to good recent books on armour by the best contemporary experts who have made a complete study of the subject.

The brass of Sir John D'Aubernoun, (fig. 3) is unique in this country in that it shows the knight holding a lance as well as wearing a sword. He wears a suit of chain mail. The only other knight to hold a lance is the Duke of Boleslaus, Lubiaz, Poland, *c.* 1300. He also wears chain mail, as do two other knights at Lubiaz, both of about the same date.

Sir Roger de Trumpington (1289), Sir Robert de Bures, Acton (1302), and Sir Robert de Setvans, Chartham (1306), all wear chain mail (figs. 5, 6 and 7).

The first half of the fourteenth century was a period of transition from chain mail to the later complete plate armour of the fifteenth century (fig. 22), as can be seen by the illustrations of Sir John de Creke, Westley Waterless, 1325 (fig. 9); Sir John D'Abernoun the younger, Stoke D'Abernon, 1327 (fig. 4); Sir John de Northwood, Minster in Sheppey, 1330 (fig. 10); Sir Hugh Hastyngs Elsing, 1347 (fig. 11).

The next sixty years showed a marked change from the earlier suits of armour. It had to combat attack by newer weapons, so plate was introduced for better protection giving a clean neat appearance. The head was covered with a basinet – a pointed steel helmet. A leather jacket – the jupon – made its appearance. This was decorated with heraldic arms and devices of its owner.

The fifteenth century saw further and elaborate changes in the suit of armour. Figure 28 shows a suit of complete plate armour of the fifteenth century. The elbows were protected by coutiers which became larger and larger, as did the besagues which protected the armpits. Later these were superseded by paldrons, massive steel plates to protect the upper arms and shoulders. The basinet was replaced by a sallet, a lighter head-piece. The armour of the Adderbury Knight, *c.* 1460, is typical of the mid-fifteenth century (fig. 33).

During the third quarter of the century the armour became simpler – the extravagances were simplified and some omitted altogether (fig. 125). The tabard, which had succeeded the jupon was blazoned with the owner's arms. This custom continued up to the mid-sixteenth century (figs. 126, 127).

The sixteenth century saw a decline in the standard of armour and its rendering on brass. It was clumsy and ugly and often heavy (fig. 41). Although many brasses which depicted this period were at least accurate, they too were clumsy and ugly in their interpretation (figs. 35, 36).

Towards the latter part of the sixteenth century there was an improvement both in the design of armour and in its interpretation on brass (fig. 40), but there was no inspired craftsman who seemed capable of breaking into fresh ground in the designing of brass memorial plates.

The development of firearms in Elizabethan times had a disastrous effect on armour. As a means of defence it was useless, for shot could penetrate the steel. However, it was still worn on account of its martial appearance and on ceremonial occasions. Seventeenth-century armour was ugly and its depiction on brass was mediocre. Jackboots replaced the armour for the leg and feet (J. Arundel, *c.* 1633, St Columb, Cornwall).

Armour was worn during the eighteenth century purely for its appearance.

8 · Civilians

Fourteenth- and fifteenth-century civilians wore simple habit, long gowns down to their feet, some with wide sleeves and tight at the wrist. A purse and rosary often hung from the belt.

In general brasses show men without hats but some seventeenth-century brasses show them wearing the side-brimmed, high-crowned hats (fig. 61).

A fine brass of a wealthy wool merchant is that of J. Curteys and widow, 1391, Wymington (fig. 48). Four attractive civilian brasses are an unknown civilian, 1370, Shottesbrooke (fig. 55); Nicholas Cantys, 1431, Margate (fig. 56); John Yonge, 1451, Chipping Norton (fig. 56); and Geoffrey Kidwelly, 1483, Little Wittenham (fig. 54).

A late brass of a civilian is William Pen, Penn, Bucks., 1637 (fig. 47).

9 · Skeletons and shroud brasses

In the latter half of the fifteenth century and during the sixteenth and seventeenth centuries a morbid, gruesome type of brass illustration appears. At Oddington, Oxford, is a shrouded skeleton eaten by worms (Ralph Hamsterley, 1510).

Figures of husband and wife in shrouds (figs. 72, 73) and a grinning skeleton in a shroud for the first president of Corpus Christi College (fig. 71) seems an odd way of wishing to be depicted for later generations to see. At Haversham, Bucks., is an effigy of a skeleton in a tomb (fig. 74).

10 · The legal profession

The legal profession is often shown on brasses; Sir Hugh de Holes, 1414, Watford, and Sir W. Laken, 1475, Bray (fig. 79), both Justices of the King's Bench, are typical examples. The brass of Robert Shiers, 1668, Great Bookham (fig. 77) is in civil gown, bare-headed and holds a book of law in his hand. He was a member of the Inner Temple. There are over sixty brasses to the legal profession.

11 · Academic dress

Various academic dresses are depicted on brasses. Professors of Law wore a similar dress to Doctors or Professors of Divinity. A good example at Merton College is a bracket brass to John Bloxham, Bachelor of Divinity 1387, and with him is John Whytton, Rector of Wood Eaton, 1420. David Lloyde and Thomas Baker, All Souls, Oxford, are also depicted together on one brass. They both died on 24 December 1510 (fig. 80).

12 · Crosses

This was a fairly common type of memorial that came into use early in the era of brasses, but few have survived. There are considerable numbers of despoiled casements remaining, that once held a cross. A demi-effigy appeared in some cross heads – a good early example is that of Richard de Hakebourne, 1311, Merton College (fig. 171). A magnificent cross – without an effigy is that at Grainthorpe, Lincs (fig. 94).

A most distinguished but small cross-effigy to William de Herleston, c. 1360, priest, Sparsholt, Berks., demands special attention (fig. 162). He is placed within the octofoil cross (damaged). The graphic lines of the figure show that the designer was a draughtsman of skill and of considerable artistic merit. Another type of brass, the bracket brass, like the cross-brass has a long support staff. A fine example is the Foxley brass at Bray, Berks.

Symbols of the four Evangelists are commonly found at the four corners of marginal inscriptions. St John – the eagle; St Luke – the bull; St Mark – the lion and St Matthew – the angel (fig. 95). These are usually found in quatrefoils or circles. The Holy Trinity is frequently displayed on brasses – one of the finest known examples is at Childrey, Berks., on the memorial of Joan Strangbon, 1477 (fig. 86). The Blessed Virgin appears on several brasses. Sir Thomas Stathum, 1470, appears with his two

wives and above him is St Christopher, on his right is St Anne and the Virgin and on his left the Blessed Virgin and Child (fig. 45).

On the brass of Bishop John Avantage, 1456, Amiens, a pictorial composition is made with the figures of the Virgin and Child, the bishop and St John (fig. 215). A similar pictorial composition is seen on the brass of George Rede, Rector, *c.* 1500, Fovant, Wilts (fig. 209). There the Virgin is kneeling in the middle, on the left is the angel Gabriel, on the right the Rector himself. These pictorial panel compositions are frequently in the nature of a book illustration, to which they owe their origin. Figures of saints and angels appear on some brasses: St Christopher at Weeke, Hants (fig. 99), at Tattershall, Lincs. (fig. 100), and St Ethelbert at Hereford Cathedral, *c.* 1290.

The soul of Walter Beauchamp, *c.* 1430, Checkendon, Oxon., is taken to heaven in a sheet held by angels. Heart brasses with scrolls issuing from the heart are another form of memorial. These record the burial of the heart, the body having been buried elsewhere. Hearts are sometimes shown held by hands (e.g. John Merstun, Lillingstone Lovell, Bucks, 1446).

13 · Heraldry

In medieval times the use of colour was general. The inside of cathedrals and churches were a blaze of colour; coloured glass windows, murals, rood screens, royal arms (later), tombs and other memorials all contributed to this love of colour display. Metal effigies were gilt and burnished. Shrines were encrusted with gold and jewels. Mosaics and enamels offered another form of decoration. Numerous brasses contained enamels of heraldic colours, now nearly all lost. This can be seen by the remaining 'tooth' cut into the metal to hold the enamels.

Heraldry offered an excellent opportunity for the use of colour. In the early part of the twelfth century knights decorated their shields with bright colour. In the thirteenth century it became the fashion to decorate the gown which knights wore over their armour with various devices (hence 'coats of arms').

Brasses are rich in the display of heraldry, not only in shields but on the vestments worn by both sexes. The men wore fine displays on the jupon or the tabard and on collars. The ladies wore heraldic mantles with beautiful designs. Some of the devices used are obscure, but they often took the form of puns – Foxley, foxes, Barley – barley and Setvans – seven winnowing fans, are just three examples from a considerable number. The language of blazonry is derived largely from Norman French.

14 · The wool merchants and the staple of Calais and other merchant traders

One of the chief industries of England in the Middle Ages was the wool trade. There were two principal districts where the wool merchants operated – the Cotswolds in Gloucestershire, and in Lincolnshire around Algarkirk and Stamford, Beds., Herts., and Bucks., also had wool trades, but on a smaller scale.

The sheep merchant of the Cotswolds was by far the most important. He had an ideal grazing land and the finest wool was obtained from sheep of the Cotswolds. Northleach was the centre, and every spring merchants came from far away lands to trade. The English wool merchants became wealthy and they supported the building of churches within the district of their sheep-farming land. Brasses were laid down in the churches to their memory when they passed away.

In Northleach Church there are several brasses to these wool merchants. Thomas Fortey, 1447, John Fortey, 1458 (fig. 51), John Taylour, 1490 (fig. 111), Unknown Woolmen, 1400 and 1485, Thos. Bushe, 1526 (fig. 103). Good brasses to other wool merchants are to be found at Wymington, Beds., John Curteys 1391; Chipping

Campden, William Grevel 1401; Lynwode, Lincs., John Lyndewode 1419; Standon, Herts., John Feld 1477; Stamford, William Browne 1489; Thame, Geoffrey Dormer 1502, and many others to a total of about three dozen brasses. The wives are often shown with their husbands and children. Sometimes sheep and woolpacks were introduced into the design of the brasses, as well as individual merchants' marks (figs. 104, 105).

Wool merchants who traded overseas had to be members of the Staple of Calais, founded by Edward III soon after the capture of Calais. It had strict laws, had its own officials, and was exempt from the jurisdiction of magistrates. It was made an act of felony for any but its members to trade in staple merchandise.

The arms of the Staple appear on many brasses of the Wool Staplers (figs. 103, 106). John Feld and John Curteys were mayors of the Staple.

There were numerous other trading companies whose members displayed its arms on brasses. The Merchant Adventurers founded at the end of the thirteenth century was an important company, but its arms are not found on brasses until over two centuries later. The Mercers Company arms for those trading in fabrics often appears with the Merchant Adventurers arms. The brass of John Terry, 1524 (fig. 53), is such a brass. It also included his own mark and the arms of Norwich. Some of the other merchant companies whose arms appear on brasses include the Goldsmiths, The Skinners, the Grocers, the Drapers, the Haberdashers, the Merchant Taylors whose arms are shown in fig. 114, the Salters, the Fishmongers, the Ironmongers, the Vintners, the Clothworkers and the Brewers. Often devices depicting their trade are incorporated in the design of the brass as well as their own merchant's mark (figs. 104, 111). A rebus appears on the brass of Richard Solwell, a member of the Haberdashers.

Caldwell or Colwell

15 · *Ladies on brasses*

Women's fashions are well depicted on brasses, though perhaps their head-dresses are more interesting than their costume. The long flowing gowns with perpendicular lines are often elegant. This can be seen on numerous fourteenth- and fifteenth-century brasses, but by the time of the late Tudor and Elizabethan times the dresses with all their elaborate decorations had become something to be admired for their details rather than for their elegance. The brass of Lady Creke, 1325 (fig. 9), is simple in the extreme, her long flowing mantle held by a cord across the breast, together with a subtle swing from the hips gives the figure great charm. Two small brasses of outstanding elegance are Margaret Peyton, 1484 (fig. 140), and Margaret Dayrell, 1491 (fig. 141). Margaret Peyton wears a gown of Venetian brocade with a most intriguing design. She has a wasp-like waist, a necklace of jewellery and a butterfly head-dress. Margaret Dayrell wears a simple gown; this, too, is narrow at the waist and is pulled up to show part of the underdress above her feet. She, too, wears a butterfly head-dress. The skill of draughtsmanship, dignity and elegance shown in this small brass (31 in.) make it outstanding.

The large quadrangular brass to Donna Branca de Vilhana, c. 1500, Evora, Portugal, (fig. 203), is a distinguished brass of Portuguese craftsmanship. It is not a Flemish product and is not even a 'blood relation', so different in character is it to those found in northern Europe. Another large quadrangular (fig. 202) brass to Herzögin Sidonien, 1510, Meissen, is by the German sculptor Vischer. Compare these two brasses; only ten years separate them, but see how different they are in outlook, design and technique, coming as they do from different parts of Europe.

Lady Maud Foxley, 1378 (fig. 116), shows her wearing a nebule head-dress. She is part of a bracket brass with her husband and his second wife. This brass was once full of coloured enamels, as can be seen by the 'tooth' remaining on the brass.

A unique head-dress of most unusual design is that of Joan Peryent, 1415 (fig. 135). Joan wears an S.S. necklace and a swan brooch.

The horned head-dress of Katherine Quartremayn, 1420, is another example of an elaborate type of head-wear. Alice Hyde, 1567 (fig. 142), is a graceful figure, much better than most of this period. Her open gown shows the beautiful decoration of the under-garment. About the middle of the sixteenth century ladies wore heraldic mantles – Lady Verney, 1546 (fig. 121), Lady Katherine Howard, 1535 (fig. 123), Unknown Lady, 1535, St Helen's, Bishopsgate (fig. 122). Their bottle-shaped figures are not elegant, but their heraldic display compensates for their lack of beauty.

In the seventeenth century ladies wore a masculine type of wide-brimmed hat – a distinguishing characteristic.

16 · Widows and spinsters

The widow could be distinguished by the wearing of a long veil which made an attractive decoration on the brass, see Elyne Cerne, 1393 (fig. 17). Her dress consists of a kirtle, mantle and head-dress with veil.

A spinster was depicted on brasses with long flowing hair and if she died young a wreath of flowers encircled her head (fig. 148).

17 · Children

Medieval families were large. Ten or twelve children were common. Geoffrey Dormer, Thame, Oxon., 1502, had two wives and twenty-five children. Children in cradles are found on brasses. Stillborn children are shown with their mother in bed, the infant lying on the bed-cover – Anne Savage, 1605 (fig. 212).

Small brasses of children's dress are common but not usually very interesting. An exception is the family of John Feld senior and John Feld junior at Standon, Herts. (1474 and 1477). The seven children are full of character, all different. It is a lively brass and of exceptional merit (fig. 150). Two trios of children – not exceptional but with charm – are the daughters of R. Tylney, 1506, Leckhampstead, Bucks. (fig. 149), and the daughters of Wilmotta Carey, 1581, Tor Mohun, Torquay. Elizabeth Culpepper, 1634, Ardingly, Sussex (fig. 146), is a charming figure of a young girl who died aged 7.

18 · Ecclesiastics

Of all the people portrayed on brass, ecclesiastics are the most interesting, because it is under this classification that there are numerous portraits of our parish priests of the Middle Ages. An excellent portrait gallery showing the character of many ecclesiastics could be built up by an observant and understanding individual who has the time and interest to reproduce the incised brass effigies as 'positives'. This is necessary because a 'negative' rubbing does not give the true character likeness. There are numerous portraits in other classifications of brasses, but it is in the ecclesiastics that the portrait dominates. Why is this? The priest was concerned with both the living and the dead. He was a man of some culture and education. He would often see a brass memorial effigy laid in his church of one of his parishioners – and the effigy was not like the individual he knew in life. So very naturally he decided that when his turn came to be laid at rest the effigy would be a portrait of himself.

This would not be difficult. He would know the local brass workshop or failing this he would engage a draughtsman to make a portrait of himself to be used later on his memorial.

Portraiture was a strong feature of medieval art. The illuminated manuscripts are full of portraits; the monks would draw and paint each other for the illustrations. Portraits appear in stained-glass windows, in sculpture and carvings of medieval times.

It needs a certain skill, artistic training and experience to distinguish a portrait from a stereotype face. One well versed in the art of portraiture of the great draughtsmen will find little difficulty in distinguishing a genuine portrait. Figs. 179–90 show a number of portraits. Numerous others appear in this volume and where this occurs it is indicated in the caption.

19 · Vestments

Brasses of ecclesiastics form quite a considerable proportion of remaining brass memorials. The earliest effigy brass is of Bishop Yso von Wilpe, 1231 (fig. 1). One of the best of English brasses is that of Laurence de St Maur, a priest at Higham Ferrars, Northants. (1337) (fig. 158).

Ecclesiastical vestments are numerous – in general terms the higher the dignitary the more he wore (fig. 161). The first robes with which a priest vests himself when preparing for the service of Eucharist is the amice (fig. 169), and the alb (white) which is the oldest Christian vestment (fig. 161). The stole, made of fur, was worn round the shoulders (fig. 173). The chasuble, the top vestment and oval in shape was often ornamented (fig. 170). The cassock was the everyday dress of the priest. The surplice was once a processional vestment, but in the fourteenth century it became the garment of a lower grade of clerics. The cope was a processional vestment worn over the cassock and surplice. The almuce (early form of amice) was a cape with a hood and pendant and lappets in front. It was worn for warmth in church (figs. 168, 173).

As far as monastic costume is concerned there are about thirty brasses of this nature left today – the Dissolution of the Monasteries in 1538–9 saw the destruction of a vast number. The costume consisted of tunic, scapular, gown, cowl and hood.

20 · Archbishops and bishops

These wore similar vestments to priests, but according to their rank certain distinctive ornaments were added. They wore mitres, sandals, gloves, arms, and a crozier (staff) with a small cross or crucifix was carried by archbishops (figs. 161, 198). They wore a tunic and the archbishop also wore a pall – a narrow band of white wool to place over the shoulders. From it hung two bands in front and behind. Bishops wore stockings, buskins or garters of silk. There are no cardinals on English brasses, but one appears at Cues, Germany, Cardinal Cusanos, 1464, and another at Krakow, Poland, Cardinal Cazimiri, 1500.

The Reformation almost caused the end of brasses of ecclesiastics. They preferred to be shown in civil dress. There are a few exceptions; one seventeenth-century example is that of Bishop Henry Robinson of Carlisle at Queen's College, Oxford, 1616.

21 · Inscriptions

The inscriptions on the majority of these various sepulchral monuments throughout the many centuries was simple and somewhat similar. In the sixteenth century they became personal and much larger. They gave details of the ages of the wives and children as well as the deceased. The mode appears to be: 'Pray for the soul of . . .' or 'Sir . . . gist ici' (*Sir . . . lies here*) or 'Dieu de sa alme est merci' (*On whose soul the Lord have mercy*). By the Middle Ages the inscriptions started 'Hic jacet . . .' or Jesu merci, Ladie (Ladi) help (fig. 143).

By the fifteenth century inscriptions on most types of memorials became much larger. Some inscriptions reached twenty lines or more.

Inscriptions were placed in various positions on the brasses, often beneath the

figures, though the early brasses show the inscriptions around the four sides. They also appear issuing from the mouths of the effigies, often in scrolls.

The later sixteenth- and seventeenth-century brasses show the names of the figures issuing from their mouths. These are mainly on the rectangular picture brasses.

The type of lettering used on brasses is a most interesting and lengthy study, but here it must be all too brief. Up to about the middle of the fourteenth century Lombardic letters were used. In the previous century each letter was a separate piece of brass. It was finely cut and sunk into the matrix on the casement. Then soon after the end of the thirteenth century the lettering was cut on narrow strips of brass and let into the matrix, which was usually on the edges of the casement slab. These letters were capitals. On the Continental brasses the system was similar, except that on the large fourteenth-century rectangular plates the inscription was part of the design and not *separate letters*.

After the use of the Lombardic letters Old English lettreing appeared on brasses; this was to last for about 250 years and is sometimes called 'Black Letters'.

Many of the inscriptions are difficult to read – spacing was often bad and abbreviations or excessive contractions were common. If a line fell short a decoration or simple motive would be used to fill the line. The contraction was indicated by a line placed above the nearest vowel. In a few inscriptions the letters were left standing in relief – the background having been cut away.

In the seventeenth century Roman lettering was general. Capitals and smalls were used, sometimes without much discrimination. A number of inscriptions were semi-italics, often of uneven slant.

Copper-plate engraving as used illustration founds its way into brass memorial plates in the eighteenth century. The quality varied greatly, some excellent, some badly designed and spaced. Some of the gems were those that incorporated shields or coats of arms with beautifully cut copper-plate style inscriptions.

The language used was Norman-French in the thirteenth and fourteenth centuries. Some Latin followed and this was replaced by English in the fifteenth century.

Continental brasses used Latin, but by the mid-fourteenth century countries generally used their own language. The use of Roman numerals was the general fashion, but about the mid-fifteenth century Arabic numerals were generally used.

There are a small number of signed brasses and very few dated workshops. Edward Marshall, Robert Haydock, S. Crue, S. Mann and T. Mann, Gerard Johnson, E. Evesham, G. Vaughan, G. Hornbie, P. Briggs, Crosse, Fulmer, Raynold, R. Preston, E. Colepeper, E. O. Ford, J. Hardman and Weller all designed or engraved brasses.

Samuel Pepys visited Saffron Walden to see Audley End House, and after leaving the building Pepys wrote in his diary of 27th February 1659 the following:

> In our going, my land-lord carried us through
> a very old hospital or almshouse, where forty
> poor people was maintained; a very old found-
> ation; and over the chimneypiece was *an inscrip-
> tion in brass:*
> > *Orate pro animâ Thomas Bird etc.*

The brass is still there. Master Thos. Byrd, late rector of Great Munden, his parents, his brother John and wife Joan, *c.* 1475 (*Bird* is Pepys' wrong spelling).

22 · *Palimpsests*

The word palimpsest is used to denote a vellum manuscript where the original writing has been erased so that the vellum could be used again. It was adopted to express the condition of a re-used brass either by adaption or by the use of the reverse.

Z1. Palimpsest brass (despoiled), Randworth, Norfolk, c. 1540. There are three small rectangular plates with text from Job XIX. The heart, shield and inscriptions have been lost. On reverse of the plates are Latin inscriptions from the fifteenth century; the third *e Drye civis Norwich* 1510.

There are two kinds of genuine palimpsests on brasses:

(1) Where the reverse or part of the reverse has been engraved and used for one or more memorials or inscriptions.

(2) Where the original brass has not been reversed but the design on its face has been appropriated, usually altered to suit a later memorial (but not always) when the inscription only has been altered to its later use.

Where the back of the brass shows a 'spoil' or a 'doodle' these cannot come within the range of a true brass palimpsest. They are interesting curiosities. If an incised design on a brass is dated later than about mid-fifteenth century and is on a thick brass plate it is most likely to be a palimpsest. Brass made after this date was thin in comparison with earlier brass plates.

Many brasses were destroyed during the Dissolution of the Monasteries (1538–9) and many Continental brasses were also destroyed about that time. These brasses were sent to various workshops for re-engraving on the reverse for fresh memorials. A number of the old brasses were cut down and various pieces used for different memorials and sent to different locations. It has been found possible to fit together some of these pieces, thus enabling a partial reconstruction of the original brass.

An interesting palimpsest is at Marsworth, Bucks., 1586, to Nicholas West and wife. Only Nicholas's legs remain and on the reverse of this part is a symbol of St Luke and part of an inscription. On the reverse of Nicholas's inscription is part of a chalice with figures of saints (figs. 224, 225, 226).

A flagrant example of appropriating another person's brass is at Okover, Staffs. (fig. 231, also fig. 232). Other palimpsests are illustrated. There are dozens of known palimpsests. Many more remain to be discovered as and when brass becomes loose, enabling the reverse to be seen.

23 · Continental brasses

Selected brasses from the Continent are depicted in this book (figs. 1, 2, 198, 201, 202, 203, 204, 205, 206, 215, 216).

The large quadrangular brasses of the fourteenth century are too often called Flemish brasses. These are found in various parts of Europe and are supposed to be the products of the workshops of Bruges. I have dealt with this at some length in *The Craft and Design of Monumental Brasses*. In brief there is no proof that such a workshop existed for the manufacture of brasses. They are too different to have come from one base. There were no precursors at the start of the fourteenth century in or near Bruges capable of producing such excellent works of craftsmanship. Bruges was then the great trading centre of northern Europe under the German Hanse. It is a fact that artists and craftsmen from the Low Countries and Germany traded their works in Bruges. These people were not Flemings. By the middle or latter part of the fourteenth century these craftsmen had settled down in or near Bruges and they and their followers produced craft work of great skill. In the Mosan district, east of Flanders, craftsmen in the twelfth and thirteenth centuries produced brilliant craft work with the same cold exact precision that is found in the large quadrangular brasses of the fourteenth century. It was these people, who were probably the precursors and later designers of some of these brasses.

24 · County totals of effigies and inscriptions including Wales, Scotland and Ireland

Approximate figures up to *c.* 1850 (see page 33)

COUNTY	INSCRIP-TIONS	EFFIGIES	ADDED TOTALS	COUNTY	INSCRIP-TIONS	EFFIGIES	ADDED TOTALS
Beds.	59	126	185	Northants.	94	101	195
Berks.	96	146	242	Northumberland	2	1	3
Bucks.	151	209	360	Notts.	54	17	71
Cambs.	77	97	174	Oxon.	181	242	423
Cheshire	75	9	84	Rutland	6	6	12
Cornwall	19	55	74	Shropshire	54	23	77
Cumberland	19	12	31	Somerset	112	60	172
Derbyshire	68	42	110	Staffs.	42	26	68
Devon	75	56	131	Suffolk	244	242	486
Dorset	88	33	121	Surrey	123	148	271
Durham	30	13	43	Sussex	141	118	259
Essex	112	301	413	Warwicks.	58	62	120
Gloucester	145	93	238	Westmorland	25	2	27
Hampshire	150	80	230	Wilts.	119	47	166
Isle of Wight	34	36	70	Worcs.	42	35	77
Herefordshire	41	42	83	Yorkshire	295	87	382
Herts.	106	205	311	Isle of Man	3	0	3
Hunts.	19	11	30	Scotland	2	3	5
Kent	353	435	788	Wales	41	25	66
Lancs.	83	33	116	Derelicts	27	34	61
Leicestershire	32	29	61	Museums, etc.	67	138	205
Lincs.	122	103	225				
Middx*	85	151	236				
Monmouthshire	9	7	16		1,732	1,417	3,149
Norfolk	785	305	1,090	Brought fwd.	2,833	2,629	5,462
	2,833	2,629	5,462	Grand totals	4,565	4,046	8,611

* For convenience Middlesex has been left as a county as it was when Mill Stephenson compiled his volume on the county lists of monumental brasses together with the appendix.

It is certain that not quite all incised memorial brasses from the fourteenth to the eighteenth centuries are recorded. One or two are discovered now and again. On the other hand from time to time the odd brass is stolen or damaged beyond repair by fire or war or other causes.

Just how the thousands of lost brasses would have altered our records is difficult to assess, but it would appear that the eastern counties would still have the greater number of brasses, as they do today. This is largely due to the fact that more trade was carried on with the Continent from east coast ports and towns. The merchant traders became prosperous and could afford the brass memorial. The wool merchants, too, had their large sheep farms here as well as in the Cotswolds, where one again finds distinguished brass memorials.

There are a considerable number of nineteenth- and twentieth-century brasses with effigies of different denominations throughout the country. It is hoped that these will be recorded in the near future. A rough estimate would be in the region of 300. Inscription memorial plates produced during the same period are multitudinous. These can be found in public buildings as well as in almost every church. The author recently counted four dozen nineteenth- and twentieth-century incised inscription brasses in the Holy Trinity Parish Church of Windsor, Berkshire. This was a garrison church. The majority of these inscriptions were large and elaborate, some with canopies, illustrations and regimental arms in coloured enamels. The names of several famous individuals, who were engaged in Victorian warfare, appear on these mural brasses.

25 · The distribution of brasses

Norfolk easily heads the list with 1,090 and Kent follows a poor second with 788. Kent, however, heads the list of effigy brasses with 435 as against Norfolk's 305. Essex follows closely with 301 effigies out of a total of 413. Norfolk has an area of 2,044 square miles, Kent 1,555 square miles, and Essex 1,542 square miles.

Yorkshire, the largest county, with 6,066 square miles, has a total of 382 brasses, comprising 295 inscriptions and 87 effigies. Lincolnshire, a large county with 2,640 square miles, has 225 brasses – 122 inscriptions and 103 effigies. Somerset, another large county with 2,881 square miles, has 172 brasses, made up of 112 inscriptions and 60 effigies. Sussex has an area of 1,459 square miles, with 259 brasses, 141 inscriptions and 118 effigies. Bedfordshire, a small county of 466 square miles, is remarkable in that it has over twice as many effigies (126) as it has inscriptions (59). Northumberland, with 2 inscriptions and 1 effigy, has an area of 2,018 square miles. There are 8 counties with over 300 brasses: Bucks., Essex, Herts., Kent, Norfolk, Oxon., Suffolk, Yorks. There are 15 counties with more effigies than inscriptions, including the Isle of Wight, and several with almost equal numbers. Some of the counties with a low count of effigies do, however, make up for this by the size and quality of their effigy brasses.

Population figures of medieval England are difficult to state with any degree of accuracy. It was as late as 1801 that the first strict general census was taken. Counts of cities, districts and various dioceses were taken at different periods; these gave but little help because they were not complete and usually included only able-bodied adults, though it is from these counts that an approximate total is obtained.

Plagues had a most disastrous effect on our population, as indeed it had throughout the world. The Domesday Book of 1087 gives the population of England and Wales at about 1,500,000. In 1300 it had reached 3,000,000. In 1348 prior to the Black Death it was about 3,750,000. The Black Death reduced the population by about 38 per cent. By 1400 the population was only 2,700,000. The epidemics of 1360–1 reduced it by 24 per cent, 1369 by 18 per cent, 1375 by 19 per cent, 1390–1 by 34 per cent, 1405–7 by 31 per cent, 1420–1 by 22 per cent, 1438 by 22 per cent, and 1465–7 by 19 per cent. These figures are not accurate, but must be accepted from the data available. By 1500

the population was only 1,500,000 – the same as in 1087! In 1600 it was 4,000,000 and in 1700 it was 5,500,000. The above dates of plagues give a pattern which can be discerned to some extent in the rise or decline in production of brass memorials.

In 1603 a population count of those over 16 years of age was made in different dioceses. These figures again show the dominance of population in the eastern counties, where the brass memorial is more prevalent. The first six are as follows:

DIOCESE	POPULATION
Lincoln	242,845
York	215,190
Exeter	188,873
Chester	180,632
London	148,747
Norwich	147,876

For much of the above data concerning population figures I am indebted to *Historical Demography* by T. H. Hollingsworth, published by the Sources of History Society in association with Hodder and Stoughton, London, 1963.

Included in the inscriptions are those brasses which were originally effigy brasses with inscriptions, but of which now only the latter part remains. The total of effigy brasses includes all double or more figure brasses counted as one unit, as well as a few effigy brasses of the nineteenth and twentieth centuries, mainly those known to the author.

Brasses in gilt

1. Bishop Yso Von Welpe 1231, Verden, Hanover, German work. The earliest brass incised effigy. He holds a church in his right hand and a castle in his left hand. 79 × 29 in.

2. Bishop Otto de Brunswick 1279, Hildesheim. German work. The third earliest effigy brass. The bishop holds a model of the castle of Woloenbergh – he was its builder. The bishop died aged 32. 77 × 30 in.

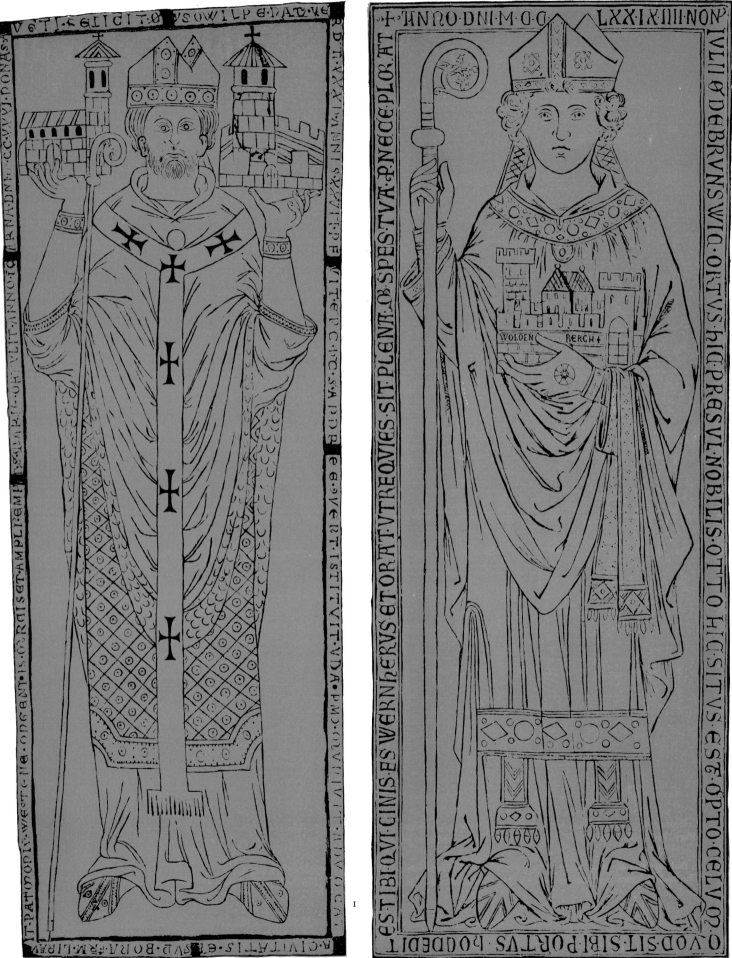

1 2

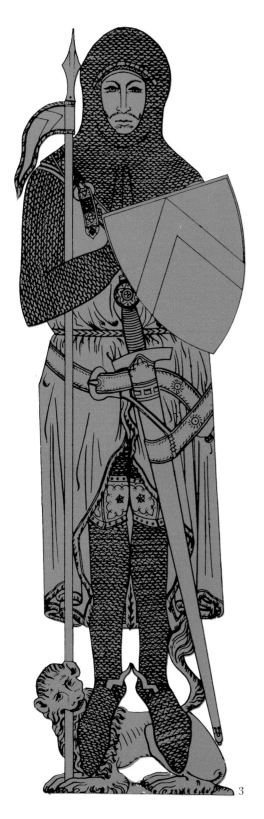

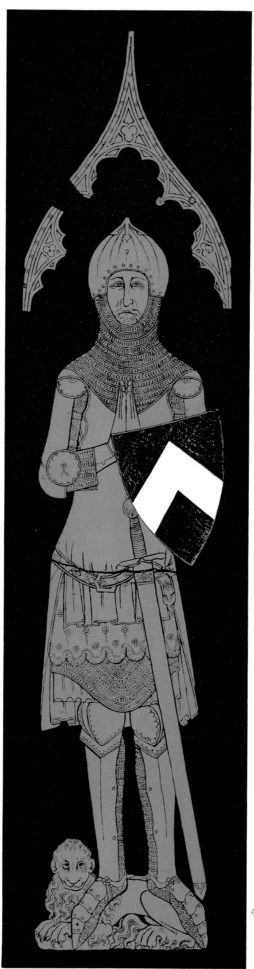

3. Sir John D'Aubernoun 1277, Stoke D'Abernon, Surrey. Blue enamelled shield. The oldest effigy brass in Great Britain. 79 in. effigy.

4. Sir John D'Aubernoun, the Younger 1327, Stoke D'Abernon. A very fine brass – the effigy has a graceful movement. The mutilated simple canopy is of the same high standard as the effigy. Effigy 64 in.

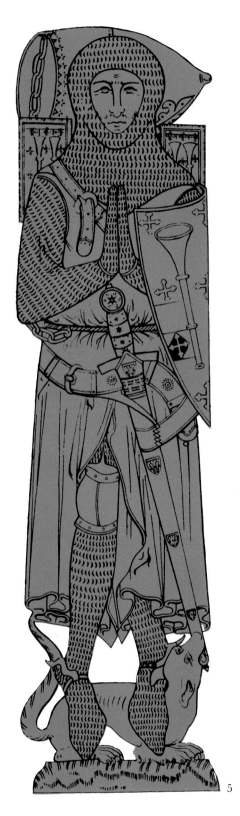
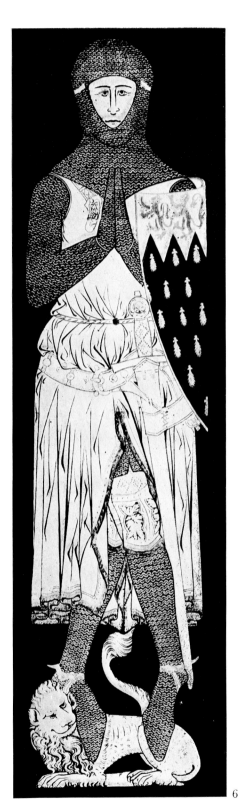

5. Sir Roger de Trumpington 1289,
Trumpington, Cambs. Note the trum-
pet on the shield – a play on the name.
The second oldest effigy brass in Great
Britain. Effigy 77 in.
6. Sir Robert de Bures 1302, Acton,
Suffolk. A good military brass. Effigy
79 in.

5

6

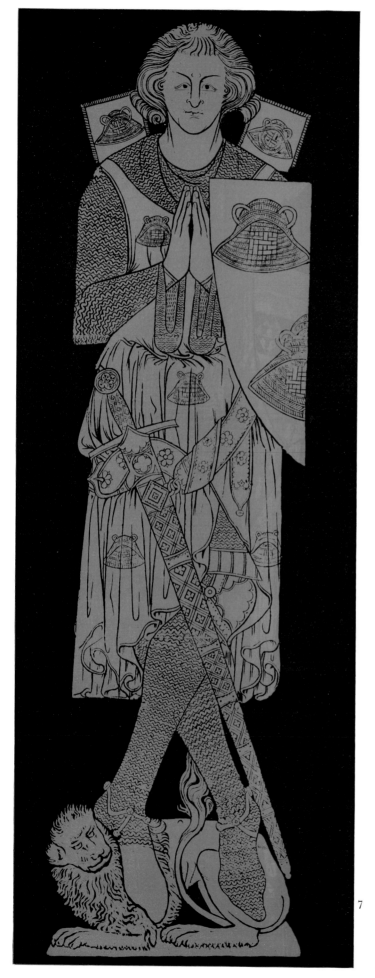

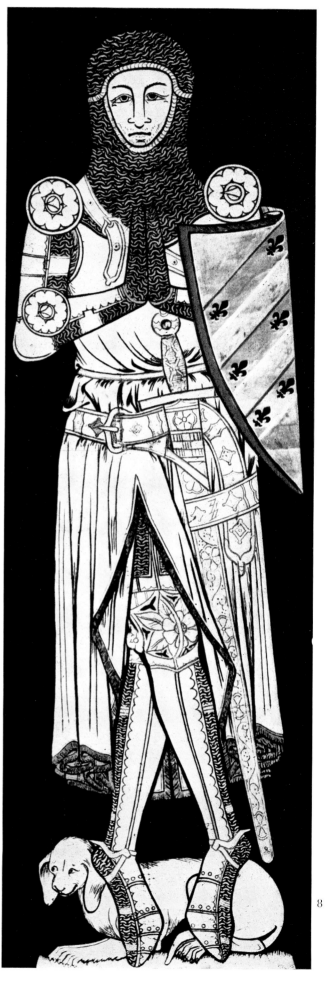

7

8

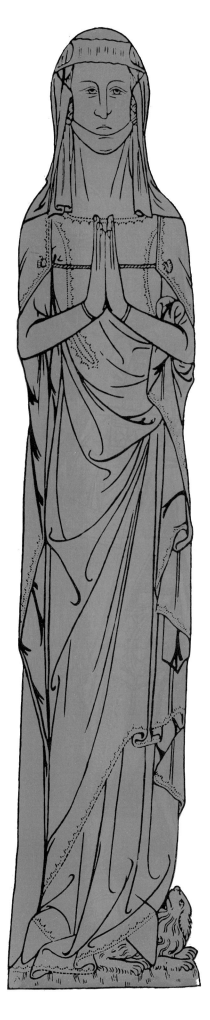

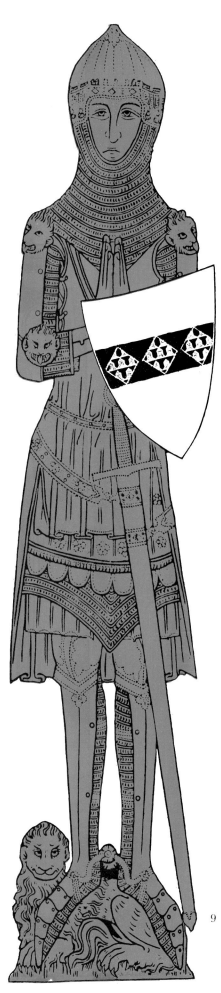

9a

9

7. Sir Robert de Setvans 1306, Chartham, Kent. One of the finest effigy brasses of all times. Effigy 74 in.

8. Sir William Fitzralph 1323, Pebmarsh, Essex. A fine brass, note the decorative design on the belt and on the scabbard.

9. Sir John Creke and wife Alyne 1325, Westley Waterless. A superb double figure brass. Effigy 66 in. Note the technique used on Alyne's gown – known as the 'hook' technique. Fig. 9a is a drawing using this technique by Villard d'Honnicourt, an important thirteenth-century French architect who travelled widely making drawings. His existing sketch book was used for references by medieval artist craftsmen.

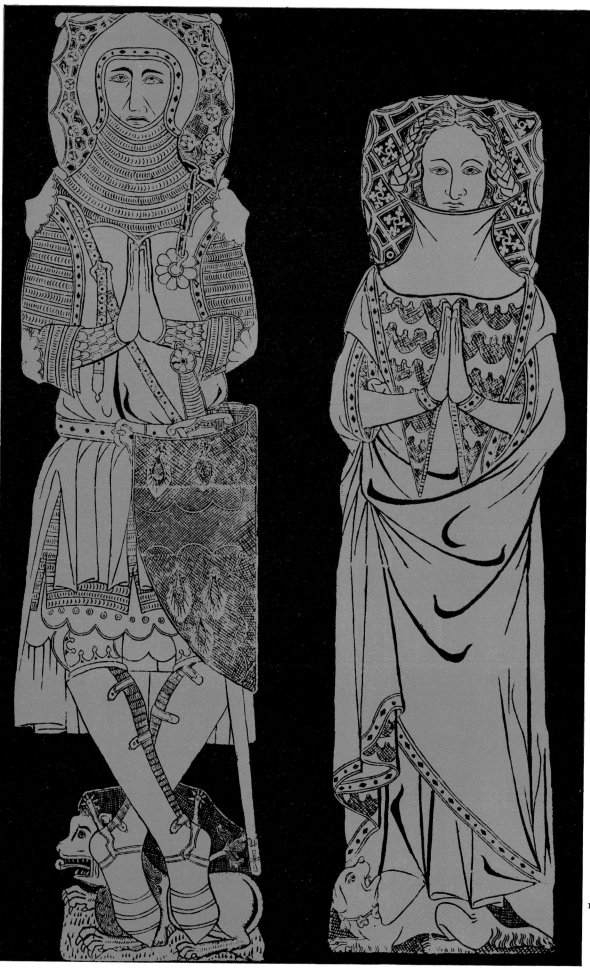

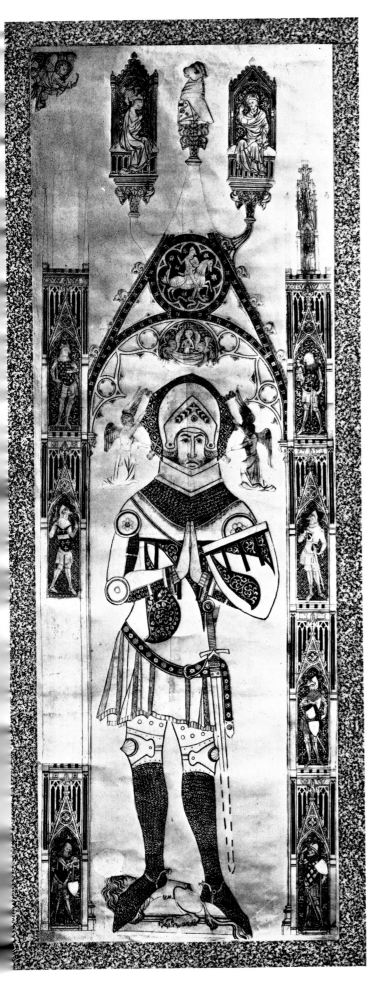

11a

11b

10. Sir John de Northwood and Lady Joan de Northwood *c*. 1330, Minster, Sheppey, Kent. Once two separate monuments. The knight's lower half is a restoration and a palimpsest. The lady's figure has also been tampered. Male effigy 71 in. deep.

11. Sir Hugh Hastyngs 1347, Elsing, Norfolk. Taken from a facsimile made in 1782 by Craven Ord. His facsimile method was similar to that of proofing an etched metal plate. The ink was forced into the incised lines – the surface wiped clean and a sheet of damp paper pressed on to the brass plate. This resulted in a left to right print. The illustration has been reversed to give the correct impression. This brass was described in a 1408 document. It gives the nomenclature used in the fifteenth century – in Norman French. Length of brass 102 in.

11a. Compartment of Hastyngs brass. Henry Plantagenet, Duke of Lancaster K.G.

11b. Compartment of Hastyngs brass. Lord Ralph Stafford K.G. Both compartments 1 ft. 7 in. deep.

11

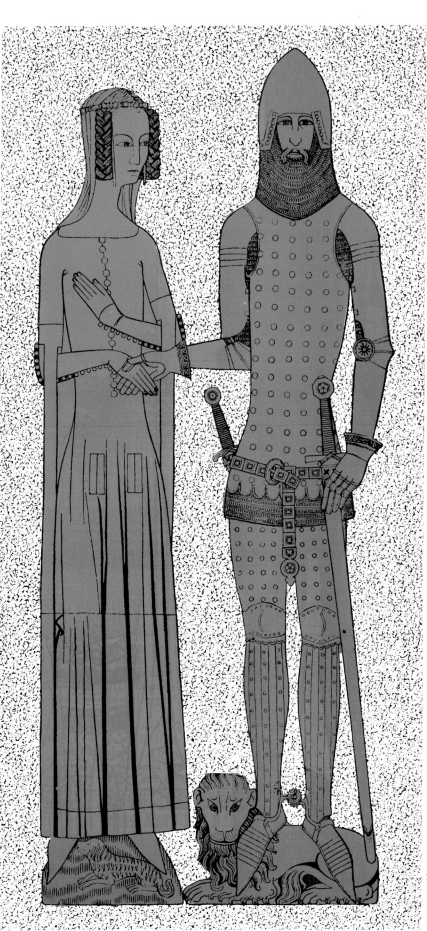

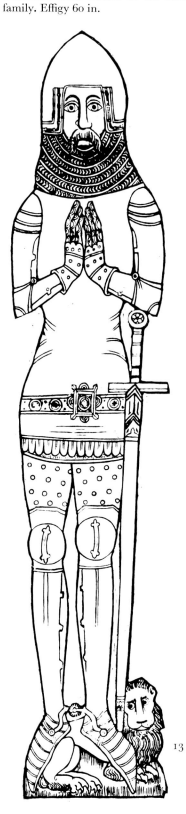

12. Sir Miles de Stapleton and wife Joan 1364. A lost brass – once at Ingham, Norfolk. From an impression in the British Museum. A charming brass – the figures are elongated and have a naïve character. The small circles are rivet heads; these can also be seen on figs. 11, 13, 14 and 16.

13. Sir Thomas de Cobham 1367, Cobham, Kent. In the church are numerous other brasses to the same family. Effigy 60 in.

12

13

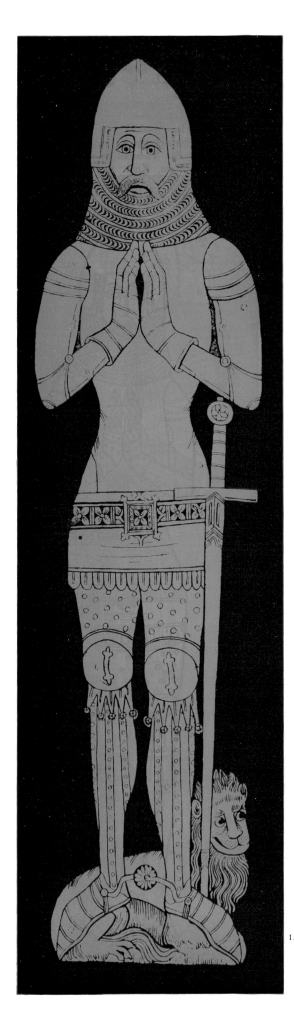

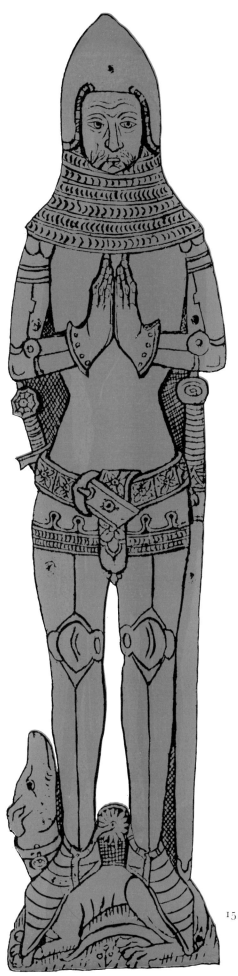

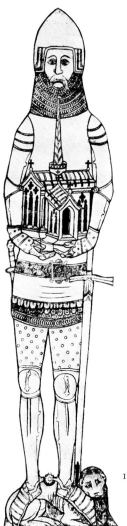

14. Sir Thomas Cheyne 1368, Drayton Beauchamp, Bucks. He was shield bearer to Edward III. Similar armour to fig. 13. Effigy 60 in.

15. Probably John Pecok c. 1380, St Michaels, St Albans, Herts. A freely drawn brass – the dog's head is too large. Effigy 34 in.

16. Sir John de Cobham 1365, Cobham, Kent. Holds a church he helped to build. Armour similar to figs. 13 and 14.

14 15 16

17. Sir Edward Cerne and wife Elyne 1393, Draycot Cerne, Wilts. The lady wears a veil denoting she is a widow. A good brass still retaining some freedom which disappeared by the turn of the century. 37½ in. deep including inscription – which is in Norman French.

18. Sir John Foxley 1378, Bray, Berks. He is on a bracket brass with his two wives. The base of the bracket springs from the back of a fox, see fig. 113. Note the helm with the fox's head – a rebus or pun on his name. Effigy 29 in. deep.

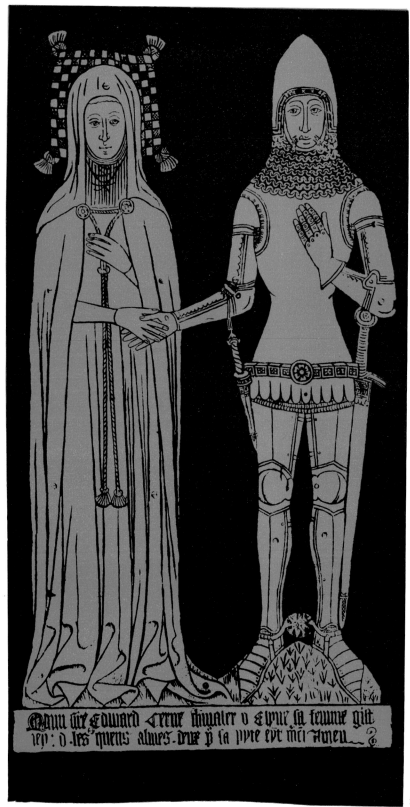

17

18

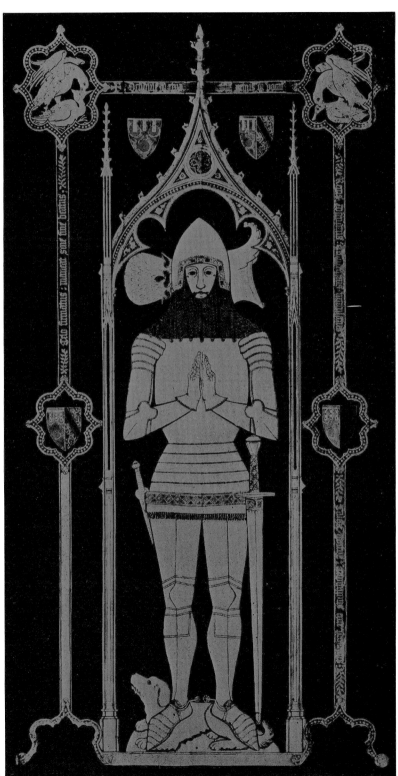

19. Sir Robert de Grey 1387, Rotherfield Grey, Oxon. Here we see the trend towards the mechanical brass figure. It is stiff but clean and simple in design. The canopy is also simple. Effigy 58 in. deep.

20. Sir Peter Courtenay K.G. 1509, Exeter Cathedral. The mechanical figure has arrived – he is more like a robot. The canopy and shields and symbols are quite excellent, which indicates that these were designed by different craftsmen of the same workshop.

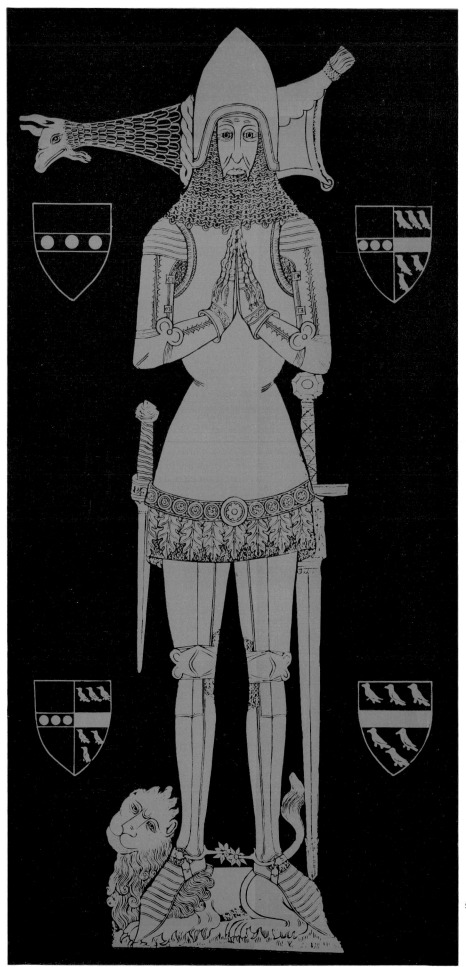

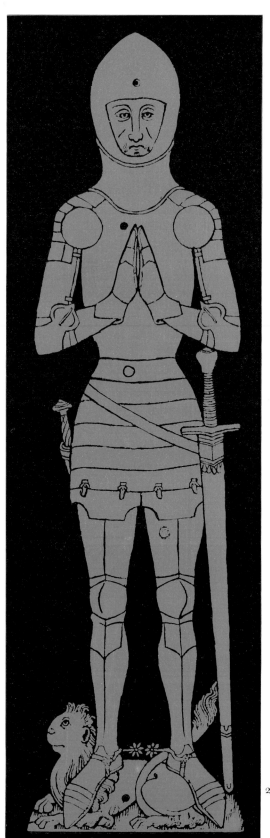

21

2

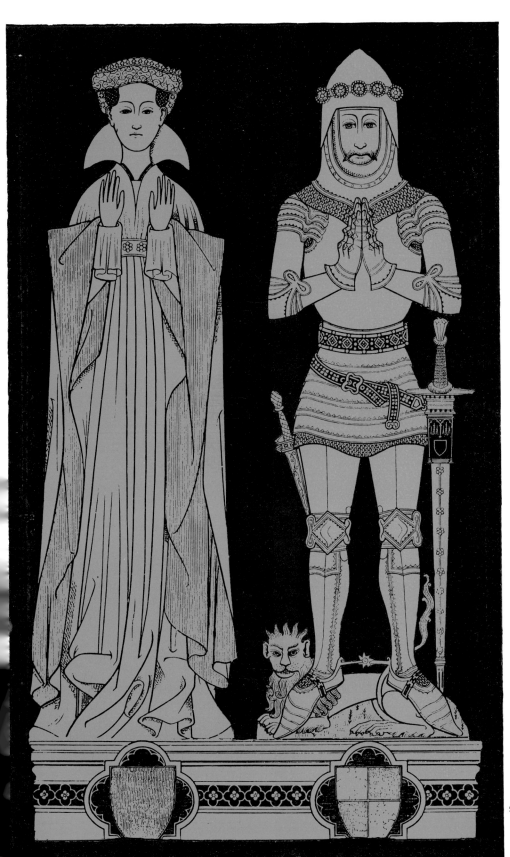

21. Sir Nicholas Dagworth 1401, Blickling, Norfolk. A really good decorative brass, though not quite without traces of the advent of the mechanical brass designers who took over in the fifteenth century. Note the grotesque helm – see fig. 112. Effigy 65 in.

22. John Poyle 1424, Hampton Poyle, Oxon. Complete plate armour, similar to fig. 28. It is almost an exact copy, except the lames have been slightly altered. Surely both are portraits. Effigy 25 in. deep. See figs. 137 and 193.

23. Lord William d'Eresby and wife Lucy, c. 1400, Spilsby, Lincs. A most interesting brass. The armour shows late use of chain mail. The execution is fine though purely of a display character, every part has been considered carefully to display to advantage the costly items his Lordship wears. His wife, who wears a long gown and overmantle is simply represented. The action of her hands is characteristic of East Anglian brasses of later dates. Each effigy 48 in. deep.

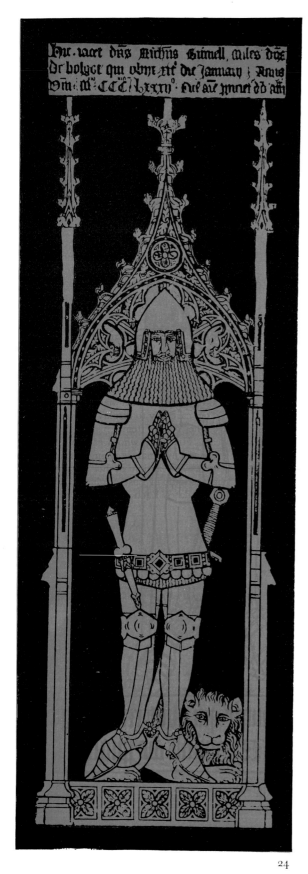

24

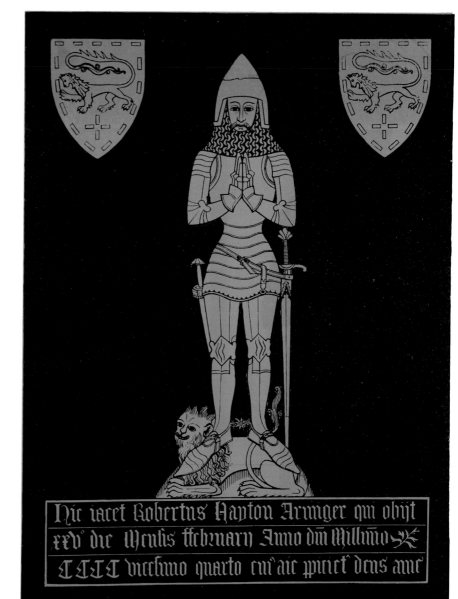

25

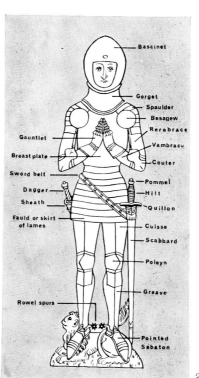

26

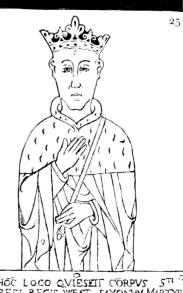

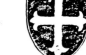

27

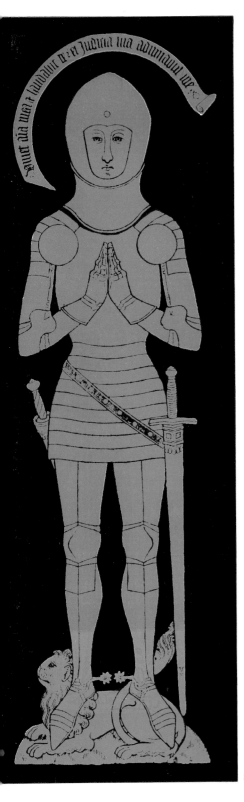

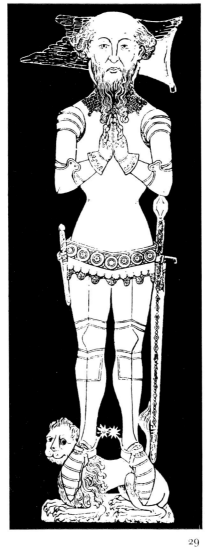

29

30

28

24. Sir Nicholas Burnell 1382, Acton Burnell, Salop. A simple, single canopy under which the knight rests at ease. Chain mail is still in evidence. Large brass. 80 in. including inscription.

25. Robert Hayton 1424, Theddlethorpe, Lincs. Though of the later date than fig. 23, he retains some chain mail and the old type of basinet. Effigy 22½ in.

26. Figure showing correct nomenclature of fifteenth century plate, although with slight variations this type of armour lasted to about 1460.

27. King Ethelred of the West Saxons died 871, Wimborne Minster, Dorset. Cut in 1440 and restored in the seventeenth century. The

inscription wrongly gives the date of his death 873. He was supposed to have been a martyr. Effigy 14¼ in.

28. Lawrence Fyton 1434, Sonning, Berks. Clean plate armour. Traces of the red enamel still remain in the belt. Effigy 39 in. deep.

29. Sir William Tendring 1408, Stokeby-Nayland, Suffolk. A rather dull brass for its large size – 5 ft. 11 in. – but interesting in that it shows Sir William bare headed and wearing a beard.

30. John Wantle 1424, Amberley, Sussex. Another bareheaded effigy. He wears a tabard over his armour. The heraldic design is not well displayed. These two bareheaded figures are surely portraits.

31. Sir Robert Del Bothe and wife Dulcia 1460, Wilmslow, Cheshire. One of several brasses showing the couple holding hands. A gusset of mail can be seen under his right shoulder. His suit of plate armour shows a departure from the earlier simple suit of Fyton (fig. 28). This brass was drawn by Holme, a Chester herald in 1572. It is still in existence (Harl. MSS. 2151). The brass was then complete with the two canopies, part of one now only remains, and part of the inscription. Effigies 60 in.

32. Sir William Vernon and wife Margaret 1467, Tong, Salop. Seven sons and five daughters (two lost). A brass full of interest.

Sir William was constable of England. He displays a flamboyant helm which became fashionable in the latter part of the fifteenth century. Eight shields are displayed; these together with the scrolls give an animated movement to the design. The elephant as a footrest is not unusual – there are several. Composition 6 ft. 3 in.

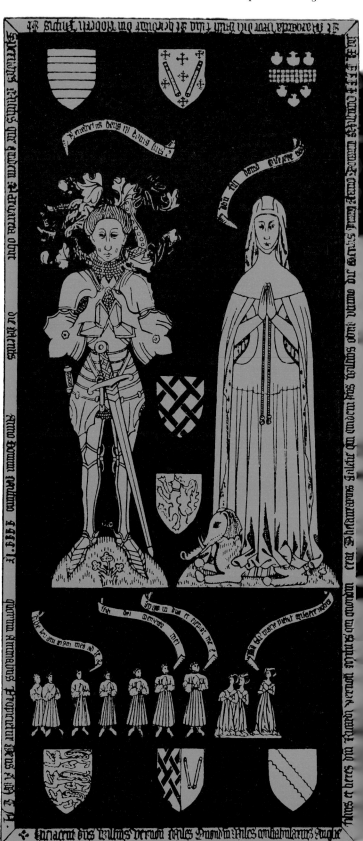

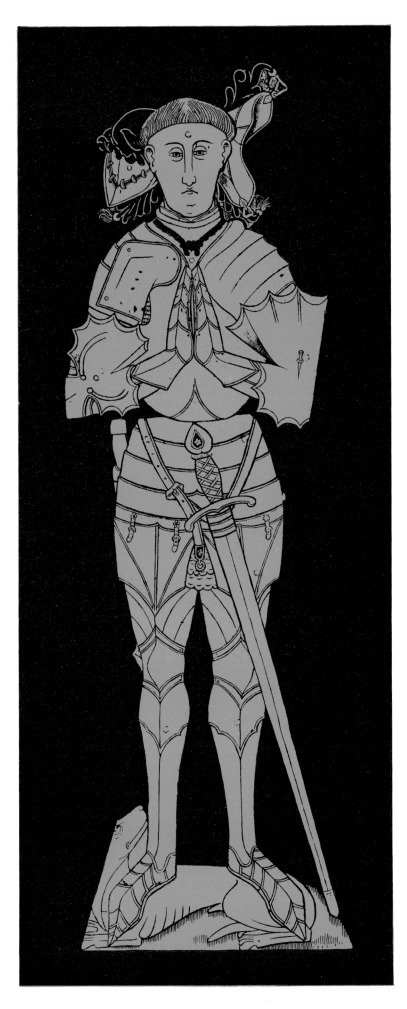

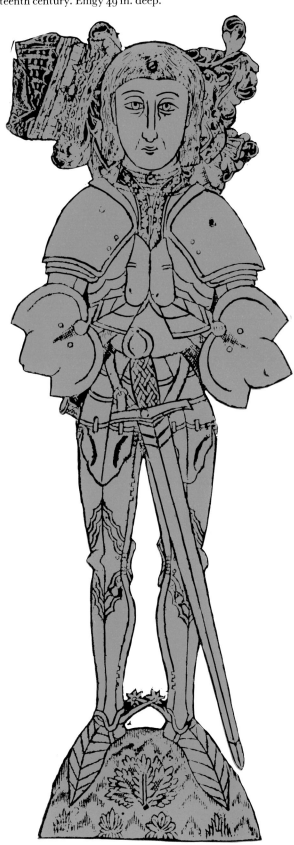

33. Unknown knight *c.* 1460, Adderbury, Oxon. This figure and the next figure show the type of elaborate helm, common on brasses of the latter part of the fifteenth century and well into the sixteenth century (see figs. 34 and 35.) The armour on brasses now show a departure from the simple style of armour worn in the earlier part of the fifteenth century. Effigy 49 in. deep.

34. Sir Anthony Grey 1480, St Albans Cathedral, Herts. Grandson of Harry Hotspur, a famous figure killed on battlefield near St Albans. Effigy 39 in. deep.

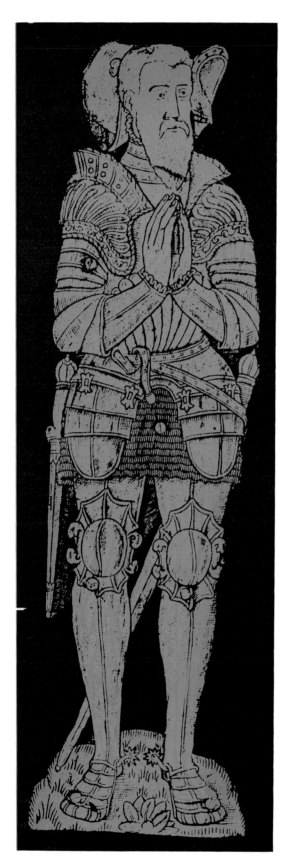

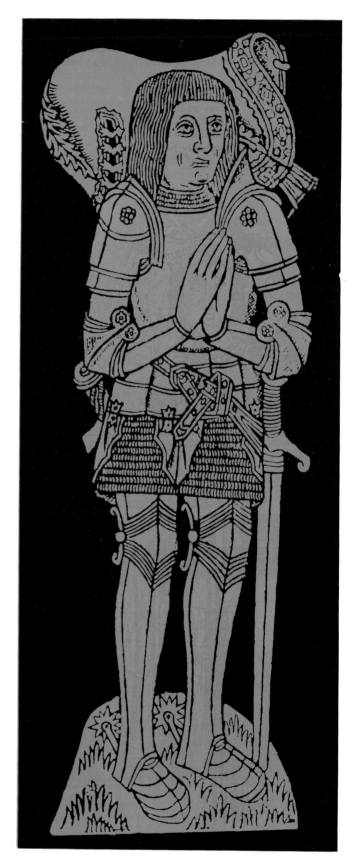

35. William Hyde 1567, Denchworth, Berks. (see fig. 142). This is far more ornate than the armour of the early sixteenth century (see fig. 36). The frills of an undergarment show at the neck and wrists; these together with ornamental shoulder-pieces, the two tassels over the skirt of mail and the ornamental knee-pieces make this brass effigy one of importance in that it shows the revival and interest that took place in the depicting of Eliza-bethan effigies. Effigy 29 in.

36. Thomas Brooke 1518, Ewelme, Oxon. Serjeant-at-arms to Henry VIII. Typical of many brasses of the first half of the sixteenth century, the figure appears to have no neck! Effigy 28½ in. deep.

37. (opposite) Sir Thomas Bullen K.G. 1538, Hever, Kent. Father of Anne – wife of Henry VIII. Sir Thomas wears the collar, mantle, garter, badge and hood of the Order. An excellent descriptive brass, but a dull overworked engraving. Effigy 60 in.

38. Sir Thomas de St Quintin 1418, Harpham, Yorks. Effigy 40 in.

39. Thomas Quatremayne *c.* 1460, Thame, Oxon. The diagonal position of the sword is a common feature of brasses of the latter half of the fifteenth century. Effigy 27½ in.

40. Sir William Harper 1573, Bedford, Lord Mayor of London. Founder of Bedford Modern School. A rare instance of a knight wearing a mantle over his armour. His wife is illustrated on fig. 47. Effigy 20 in.

41. Unknown knight *c.* 1500, Whittle, Essex. Another example of a figure without a neck! He wears his sword on the right-hand side – probably he was left-handed. Effigy 30 in.

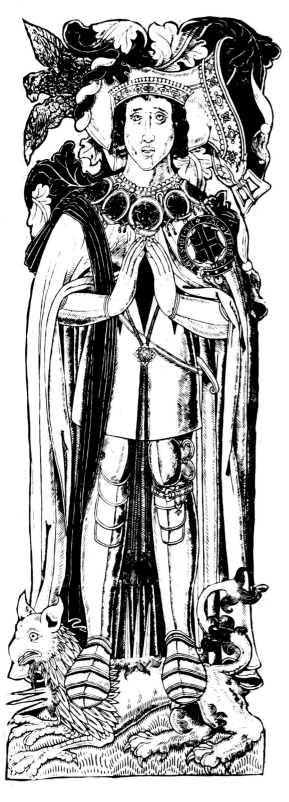

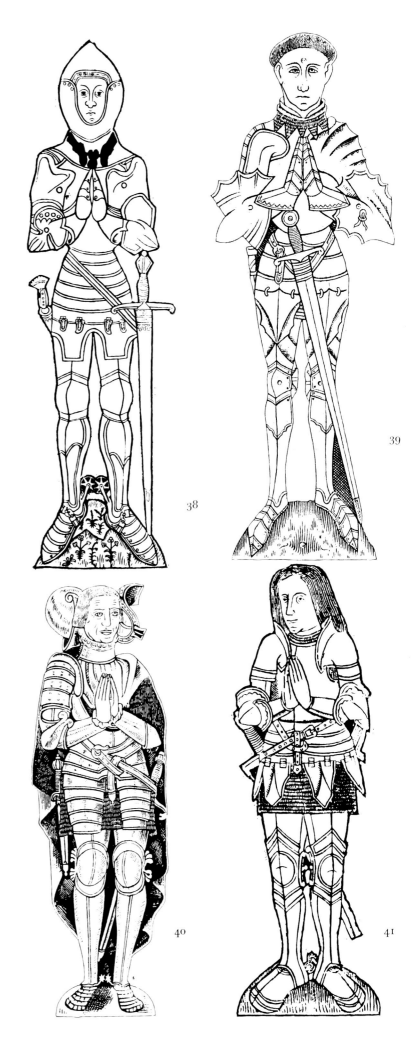

38

39

40

41

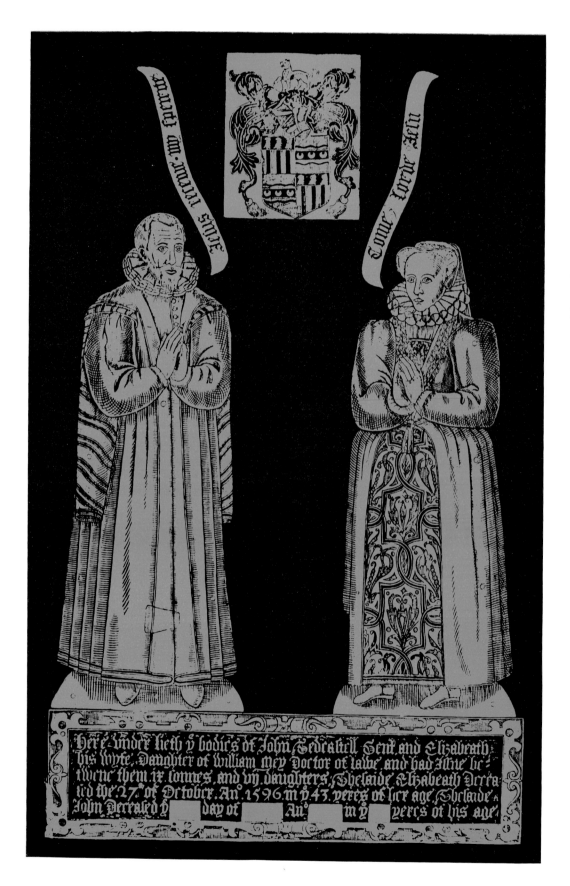

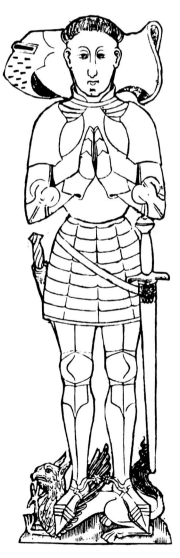

42. (*Left*) John Tedcastell and wife Elizabeth 1596, Barking, Essex. The inscription states Elizabeth died aged 43, but the blanks left to record the death of John were never engraved, Brass 45 in. deep.

43. (*Below*) Walter Grene 1546, Hayes, Middlesex. Note the strange bird-like beast at the foot – a Phoenix for long life.

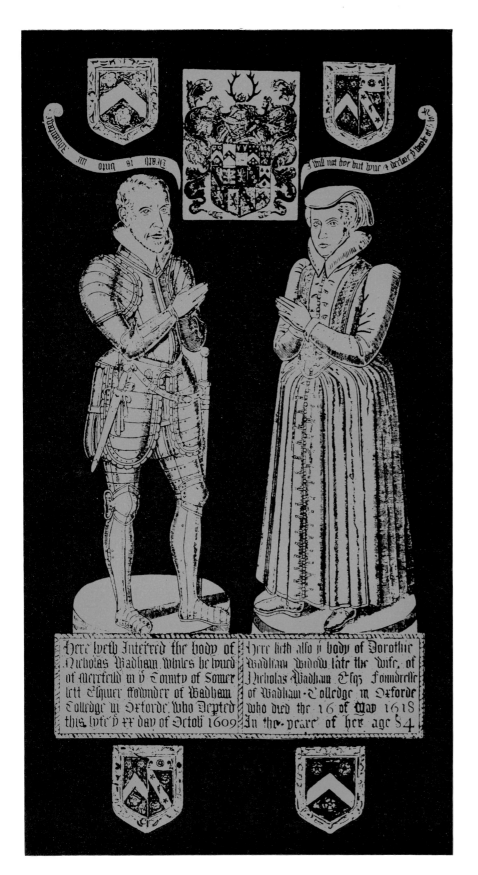

44. (*Left*) Nicholas and Dorothy Wadham 1609, Ilminster, Somerset. A late Elizabethan brass designed to impress by heraldic display and general arrangement of the units. The lady wears a Paris head-dress and a farthingale.

45. (*Below*) Sir Thomas Stathum and two wives 1470, Morley, Derbys. St Anne and the little virgin on the left, St Christopher with the infant Christ on top, and Virgin and child on the right. Brass 45 in. deep.

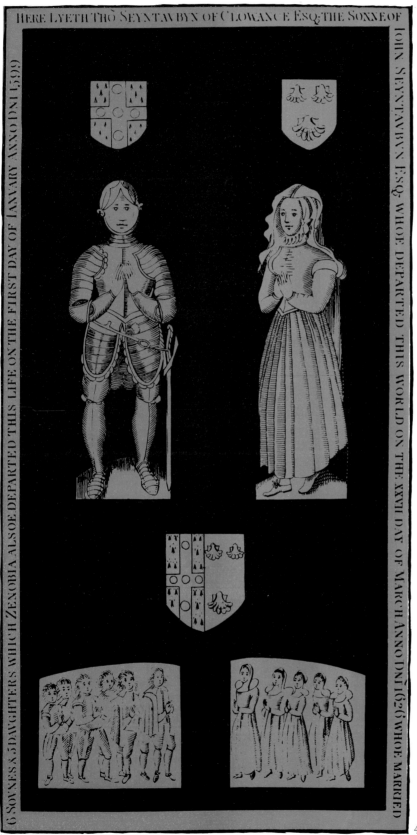

HERE LYETH THŌ SEYNTAVBYN OF CLOWANCE ESQ THE SONNE OF JOHN SEYNTAVBVN ESQ WHOE DEPARTED THIS WORLD ON THE XXVII DAY OF MARCH ANNO DNĪ 1626 WHOE MARRIED 6 SONNES & 5 DAVGHTERS WHICH ZENOBIA ALSOE DEPARTED THIS LIFE ON THE FIRST DAY OF IANVARY ANNO DNI 1599

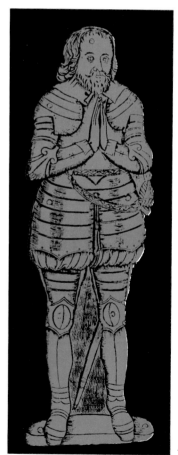

46. Thomas Seyntaubin and wife Zenobe 1626, Crowan, Cornwall. Marginal inscriptions are rare at this date. The brass is now badly mutilated. Taken from an eighteenth-century engraving.

47. William Pen 1638, Penn, Bucks. Sheriff of Bucks. A member of the family that went to Pennsylvania Effigy 25 in.deep.

48. John Curteys and widow 1391 Wymington, Beds. Mayor of the Staple of Calais. A very good canopy brass to an important wool merchant. (Large brass.)

49. Thomas Stokes and wife Ellen 1416, Ashby St Legers, Northants. Four sons, twelve daughters. Super canopy. Both wear civilian gowns – the lady a widow's veil. Trinity lost from super canopy. A clean, good, simple canopy brass – a rare design. Brass 4 ft. 6 in. deep.

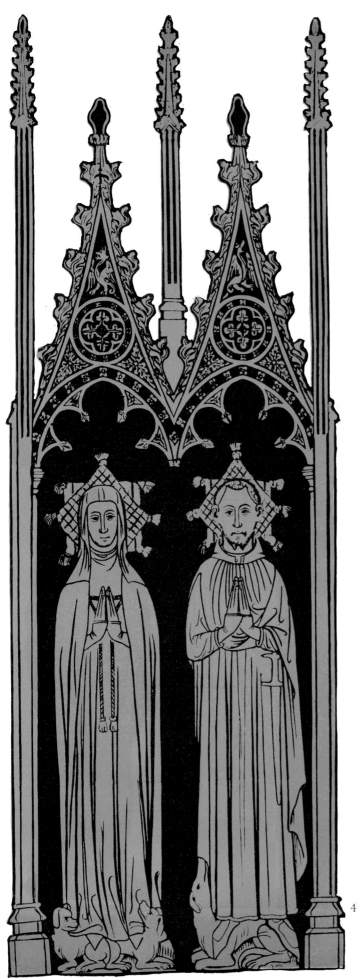

48

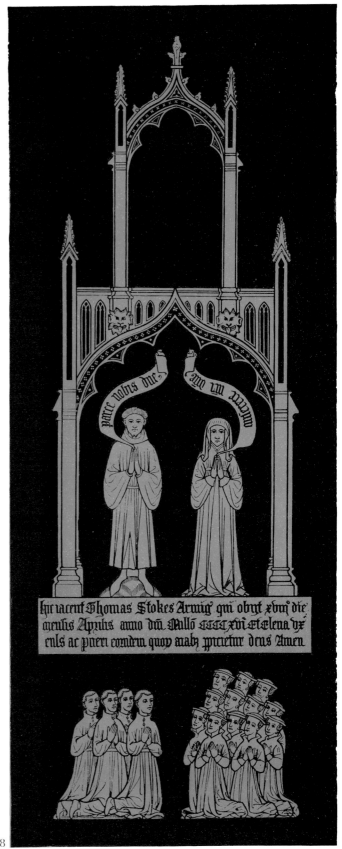

49

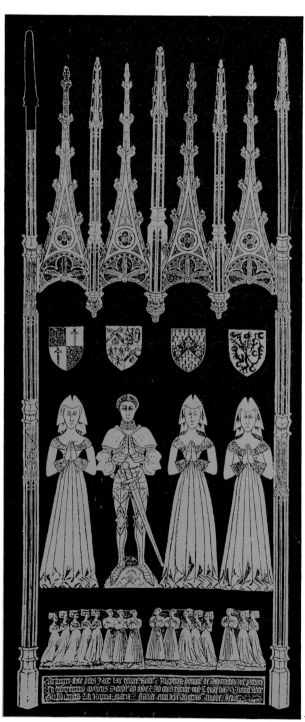

50

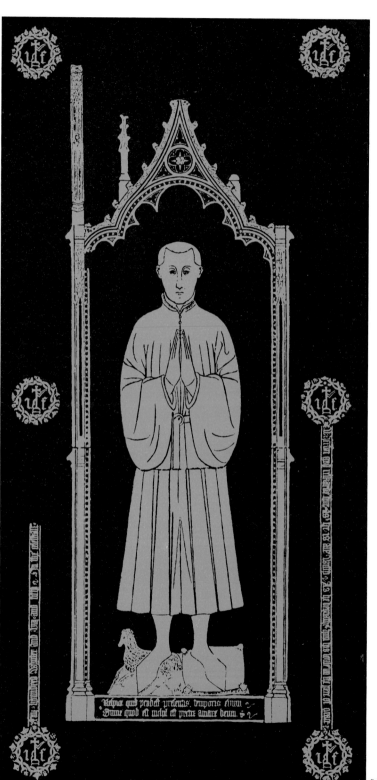

51

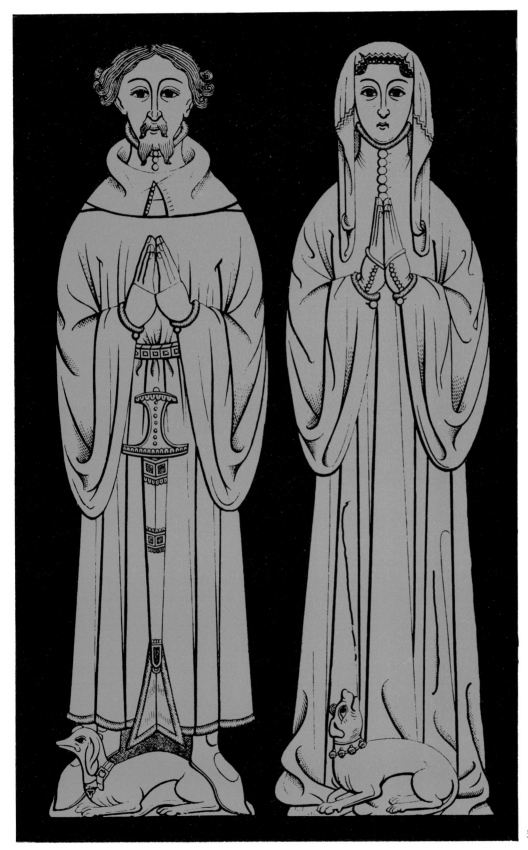

50. Robert Ingylton and three wives 1472, Thornton, Bucks. Sixteen children. Quadruple canopy. Note the diagonal position of the sword. The work in the majority of fifteenth-century canopies on brasses shows excellent craftsmanship and superb design as in this one.

51. John Fortey 1458, Northleach, Glos. Wealthy woolman who built the nave clerestory of Northleach's St Peter and St Paul Church. John has his feet on a sheep and a woolpack. See pages 25, 26 and figs 56, 60, 111.

52. Unknown civilian and wife *c.* 1400, Tilbrook, Beds. A charming double effigy brass. Both wear simple civilian gowns; they both have dogs at their feet. The civilian has an anelace attached to his belt. The anelace was a short dagger or hunting knife often worn by civilians. Effigies 3 ft. 4 in.

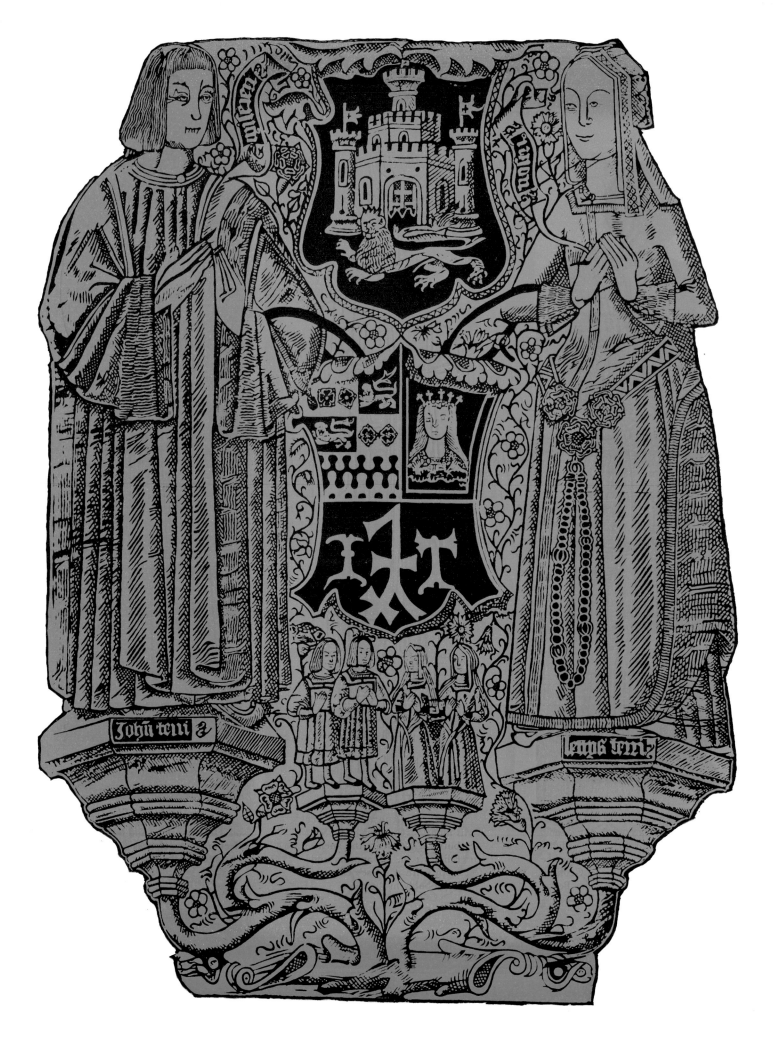

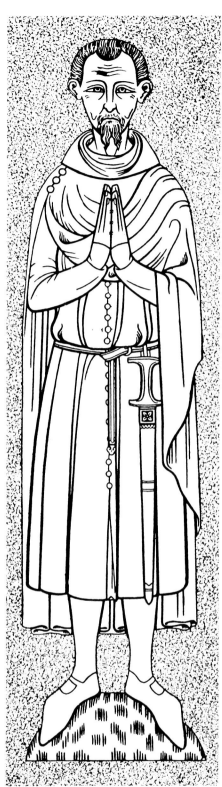

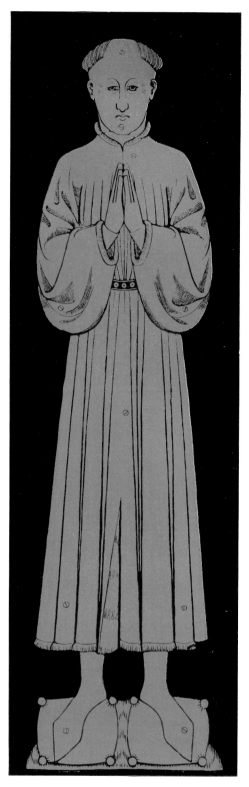

PORTRAITS OF THREE CIVILIANS
These three civilians are undoubted portraits. The linear work on these three effigies is very restrained – note the complete absence of hatching on fig. 55. 54. (*above*) Geoffrey Kidwelly 1483, Little Wittenham, Berks. Note his purse and prayer beads. The paternoster bead string, tasselled at both ends or with a tassel at one end and a cross at the other was used almost exclusively by men. On his left shoulder Geoffrey wears a hood. Effigy 28 in.

55. Unknown civilian *c.* 1370, Shottesbrooke, Berks. His mantle is fastened by three right shoulder buttons. He wears the anelace at his belt. Effigy 51 in. He appears under a double canopy with a priest's effigy of the same size – probably his brother.

56. John Yonge 1451, Chipping Norton, Oxon. He wears shoes and hose of one piece. His feet are on woolpacks – denoting that he was a wool merchant.

53. (*Facing page*) John and Lettys Terry 1524, St John Madder Market, Norwich. An unusual brass design to a wealthy merchant and wife and children. The top shield is that of the city of Norwich and the lower, Merchant Adventurers, Mercers Co. and merchant mark. The lady wears paternosters or ave-beads. Her five decades of beads are divided by large paternoster beads attached to a decorative rose buckle. The two figures stand on brackets which spring from branches of a tree.

57. William Walrond *c.* 1480, Childrey, Berks. A civilian in long gown. His hair is rolled. A very simple brass, attractive except for William's face! Depth 25 in. His wife stands with him on the brass (see fig. 139).

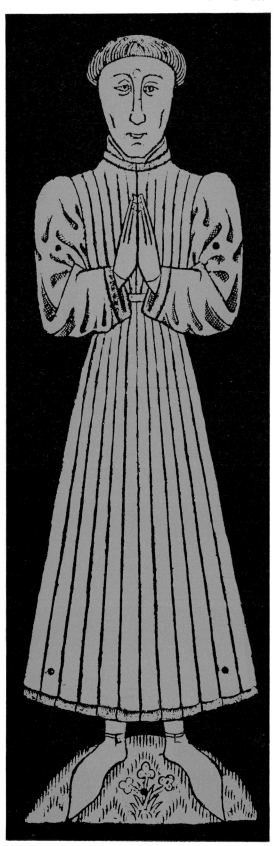

58. Robert Coulthirst 1631, Kirkleatham, N.R. Yorks. Merchant tailor of London, died aged 90. In civil dress holding book. Effigy 46 in. deep.

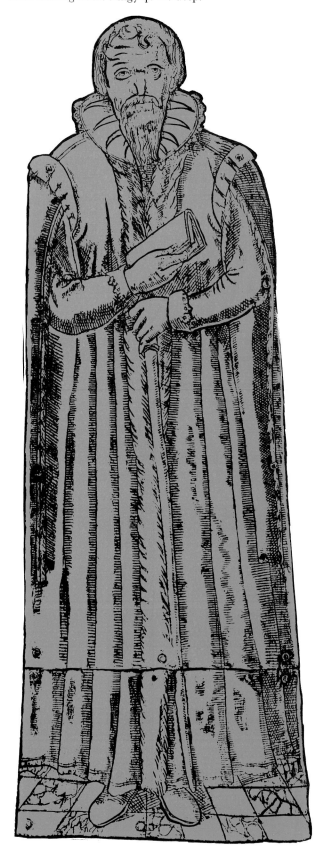

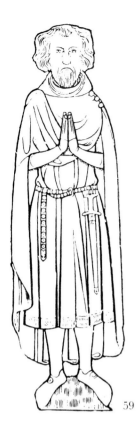

59. Sir Symond de Felbrig 1351, Felbrigg, Norfolk. In civil dress, his mantle is fastened by three left shoulder buttons, the opposite shoulder to that on figure 55. Sir Symond also wears an anelace. A portrait brass.

60. William Browne 1460, Stamford, Lincs. In the church of All Saints there are brass memorials to four Brownes – all the same family. This member illustrated below was a wool merchant of the Staple of Calais and stands on woolpacks with his wife. His two sons both appear on brasses with their wives.

61. Richard Gadburye 1624, Eyeworth, Beds. A most distinctive effigy. The gown at this date denotes a change in fashion that with a few slight alterations was to last about thirty years. The hat, too, was something of an innovation. A portrait brass.

62. John Saunders 1645, Hambledon, Bucks. He appears with his two wives on the brass. His habit is very typical of the mid-seventeenth century. The brass is somewhat crude – the technique similar to book illustrations by wood engraving. Portrait. Effigy 16 in.

59

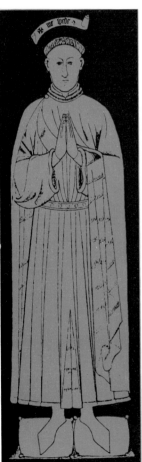

60

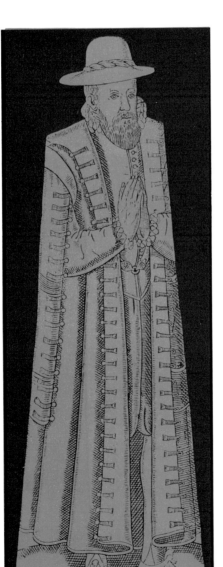

61

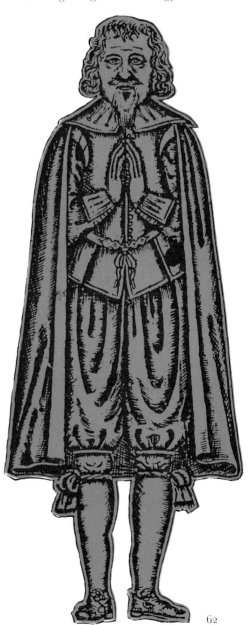

62

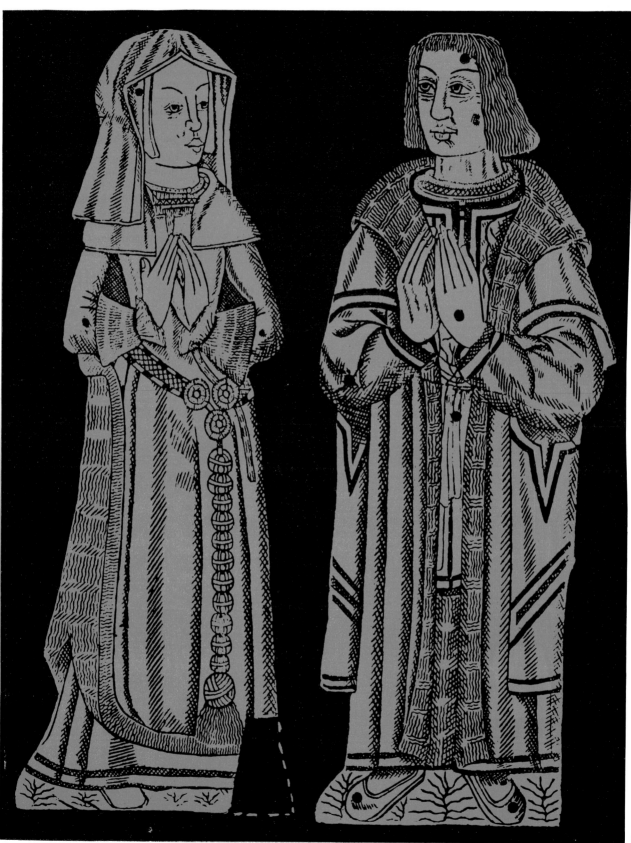

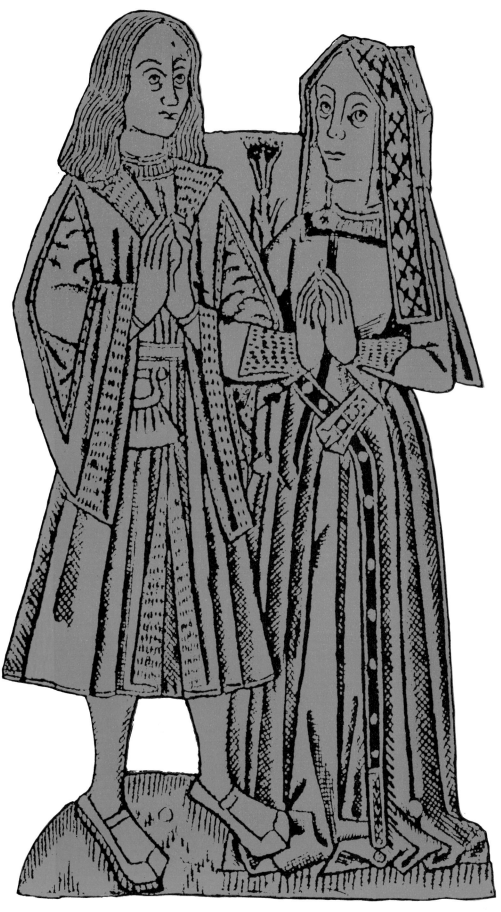

63. Civilian and Lady *c.* 1540, Little Walsingham, Norfolk. Note the large paternoster beads attached to her decorative belt by a three-rose buckle. This buckle probably symbolizes the three sets of the five mysteries in the Rosary devotion. These two figures are palimpsests. The reverse shows two parts of a lady of about 1330. A third piece known by an illustration, the reverse of an inscription to Charles Slayden 1545 (whereabouts now not known) fits to the upper part of the male effigy. Effigies 19½ in.

64. Unknown civilian and wife *c.* 1490, Brown Candover, Hants. The charm of this brass is found in the designer's success in making the two figures into one complete design. The texture of material, the lady's belt and the diamond contribute in making this brass a homogeneous pattern. Effigy 19 in.

65/66. Thomas Garrard and wife Anne 1619, Lambourne, Berks. The inscription under the figure states: *Here lyeth Thomas Garrard Gent the first sonne of Thomas Garrard in the monument on the wall above written by Alice his second wife, who died the 9th of August Anno Dni 1619 and Anne his wife the daughter of John Tutt* Esq., who died the 28th of January 1610 and in remembrance of them Thomas Garrard their sonne hath placed this marble stone over them. Effigies 18 in. Tutt's Clump, Bradfield, Berks.*

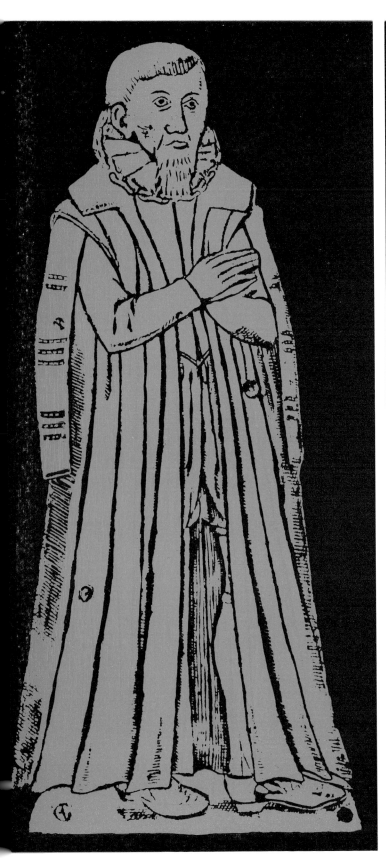
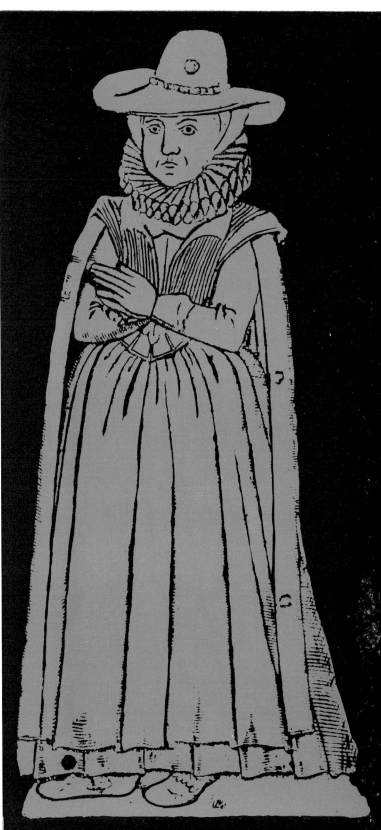

67/68. William Chapman and wife Anne 1636, Walkern, Herts. London citizen and haber-
dasher. Both in civil dress. Six sons and six daughters are illustrated on the brass, but are badly
worn. These two figures show the decline of design and engraving in brasses as the mid-seven-
teenth century advanced. Effigies 18 in.

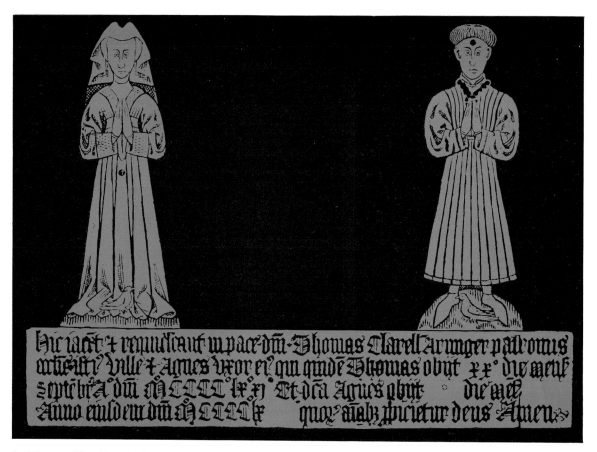

69. Thomas Clarell and wife, brass engraved *c.* 1460, Thomas died 1471, Lillingstone Lovell, Bucks. The dark collar around Thomas's neck is the collar of sun and roses – Edward IV's badge. One son and two daughters appear under the inscription. It is a small but neat brass. Inscription 23 in. wide.

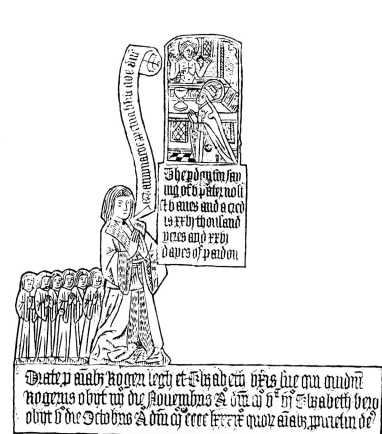

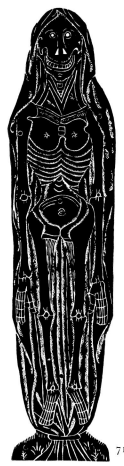

70

71

70. Roger Legh 1506. Effigy of wife Elizabeth and seven daughters lost, Macclesfield, Cheshire. The small rectangular plate at the top represents Pope St Gregory with a pardon for *XVI thousand years and XXVI days for V paternost and V dues and a cred*. Composition 22½ in. high.

71. John Claimond 1530, Corpus Christi College, Oxford. An example of the morbid, gruesome type of effigy of the sixteenth century. These also appeared on sculptural effigies, both in this country and on the Continent.

72/73. Unknown man and woman *c.* 1510, Biddenham, Beds. These two effigies in shrouds show a different interpretation of the macabre type of memorial of the sixteenth century. Gruesome memorial effigies appeared in the fifteenth century and continued on into the seventeenth century. These figures are clumsy and badly drawn. Compare the drapery with that on fig. 9. Effigies, man 17¾ in. woman 19 in.

74. John Maunsell 1605, Haversham, Bucks. Yet another example of the strange morbid type of memorial. The inscription states that John died on 25 January aged 66. Effigy 23 in.

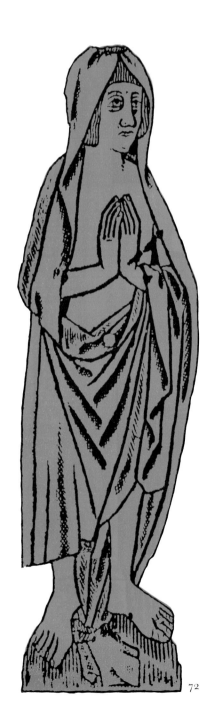

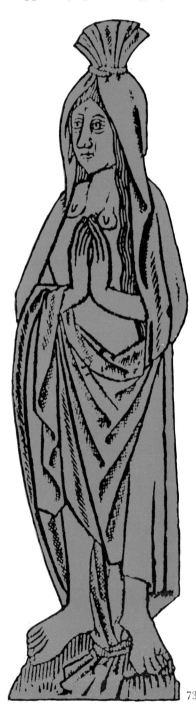

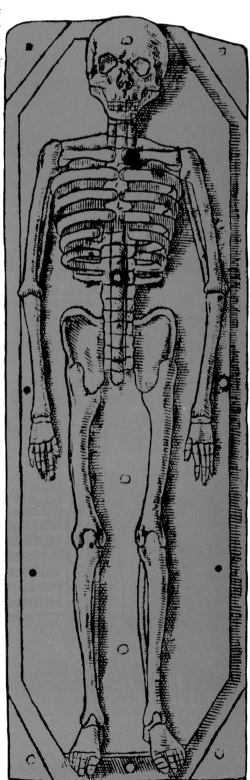

72 73 74

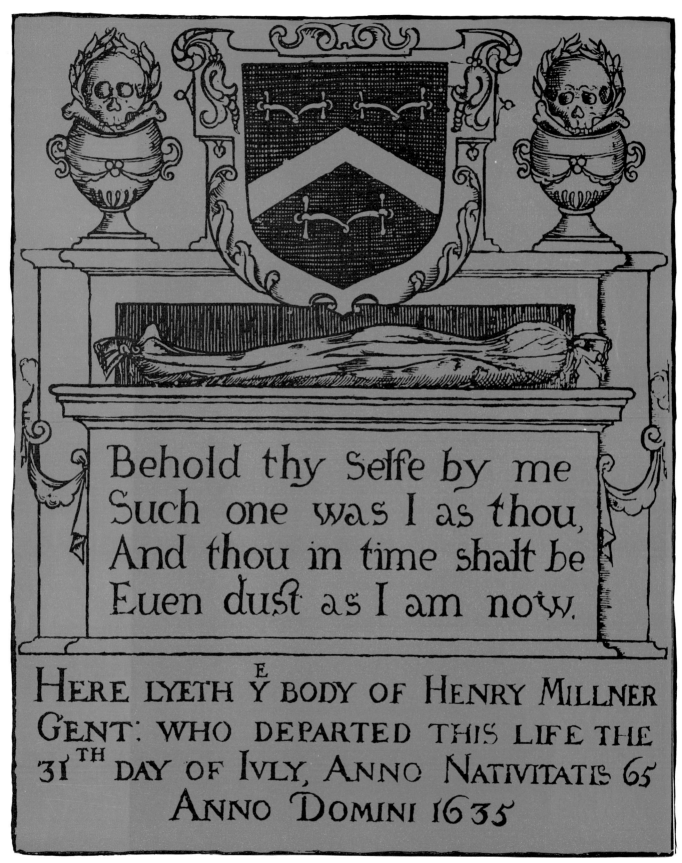

Behold thy Selfe by me
Such one was I as thou,
And thou in time shalt be
Euen dust as I am now.

HERE LYETH Y^E BODY OF HENRY MILLNER
GENT: WHO DEPARTED THIS LIFE THE
31^TH DAY OF IVLY, ANNO NATIVITATIS 65
ANNO DOMINI 1635

75. Henry Millner 1635, Wickenby, Lincs. A wall brass much in the manner of three-dimensional wall memorials. The shroud, the skulls and urns show the continuation of the macabre outlook. Depth 17 in.

Play for the soules of Master Robert ffaufax doctor of Mnsic and Agnes his Wife the Which Robert decrased the xxiij day of October the year of our Lord God m°v°rri° on Whose soules Jhu have mercy Amen

76. Robert Fairfax and wife Agnes, St Albans Cathedral. Robert was doctor of music. He died 1521. The brass was lost. However, it was known from an old drawing and in 1921 a new brass was cut from the design and laid on the floor. 25 × 16 in.

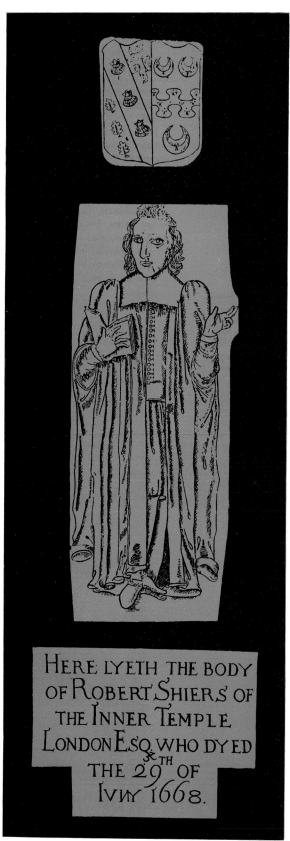

78. James Cotrel 1595, York Minster. A most attractive brass even if the figure is somewhat stilted. The detail of the costume is graphically depicted. James was a Queen's councillor. 33 in. deep.

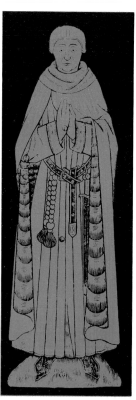

77. Robert Shiers 1668, Gt. Bookham, Surrey. A three-piece brass, 5 ft. 6 in. in length, to a member of the Inner Temple. A typical 'sketch book' type of brass common in the seventeenth century. Note the month – June or July? Surely a portrait brass.

79. Sir William Laken 1475, Bray, Berks. Justice of the King's Bench. Effigy of wife lost. He wears a fur-lined mantle with hood and coif. The latter was a close-fitting skull cap. This brass once held coloured enamels. Effigy 30 in.

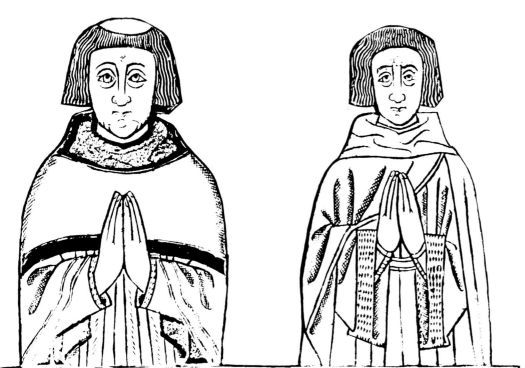

80. David Lloyde L.L.B. and Thomas Baker 24 December 1510. All Souls' College, Oxford. A rare example of two demi-effigies (male) appearing together. Lloyde demi-effigy 11¾ in.

81. John Mantock 1503, Banwell, Somerset. Physician in choir dress and cope. The brass was restored in the nineteenth century. His name appears on a brass lectern at Merton College, Oxford.

82. John Cottusmore 1439, Brightwell Baldwin, Oxon. Chief justice of common pleas. Inscription in Latin – 26 lines. His wife appears on this brass – but no children. Effigy 8½ in. deep. In the church is another brass to the same two individuals. It is a large double-canopy brass, both figures standing with five sons and thirteen daughters and four shields. The identical coats of arms appear on both brasses. (Total composition 84 in.)

80

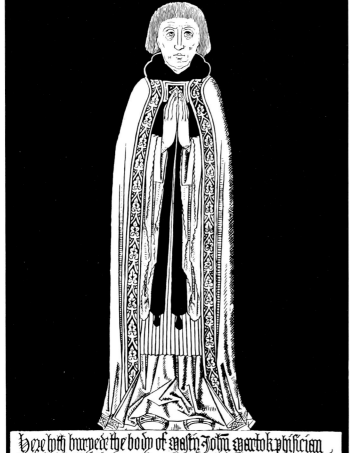

81

82

83

84

85. Thomas Payne and wife Elizabeth
1528, Hutton, Somerset. The work of
a local craftsman, it has a naïve charm
– the inscription though badly cut and
spaced fits well into the work of the
effigies. Male figure $12\frac{3}{4}$ in. deep.

83. Dame Elizabeth Goringe 1558,
Burton, Sussex. A rare instance of a
lady in tabard. Her husband's and her
own arms are quartered on it. She
kneels at a faulstool, as do the other
effigies on this page.

84. Katherine Scrop 1500, Hamble-
den, Bucks. She is depicted as a widow.
The black illustration with the white
incised lines is the correct rendering of
this brass. Effigy 9 in. deep.

85

Pray for þe soulis of Thomas payne squier [and]
elyzabeth hyis wiffe which departid þe xviii day
of august þe yere of ô lord god m ccccc xxviii

86. Trinity 1477, Childrey, Berks. On the brass of Joan Strangbon. A fine example. Probably derived from German woodcut illustrations. 20 in. deep.

87/88. Glass window in Cirencester church – emblem of Blessed Trinity *c.* 1400. The same design (88) used on a brass to Prior Thomas Nelond 1433, Cowfold, Sussex. This design appears on several brasses.

89/90. Effigy of unknown priest with St John the Baptist *c.* 1415, Aspley Guise, Beds. Both simple with good draughtsmanship. Effigies 18 in. deep.

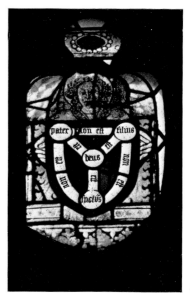

87

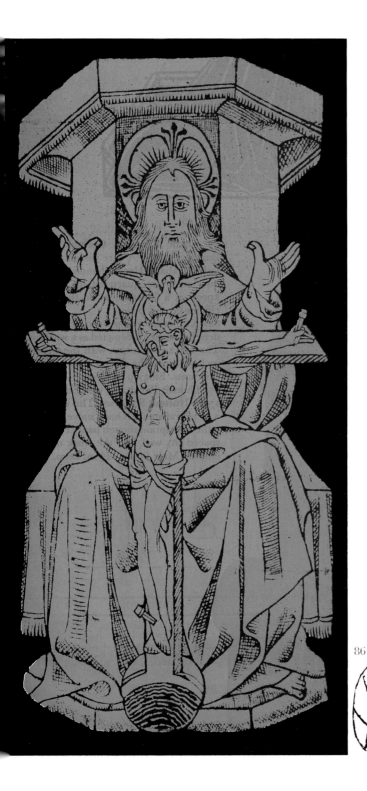

86

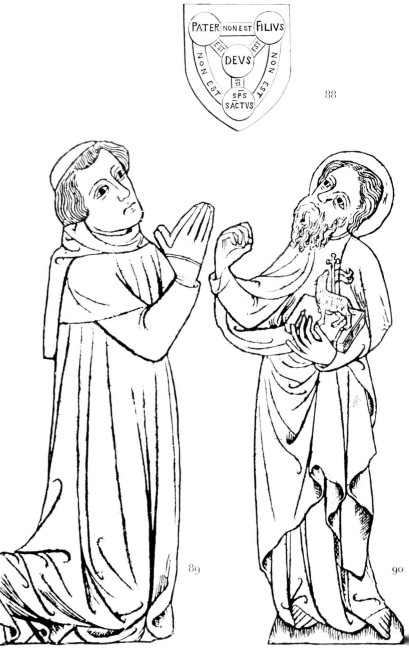

88

89

90

91. Richard de la Barre, Canon 1386, Hereford Cathedral. He wears a cope. Stem of cross mutilated – inscription lost.

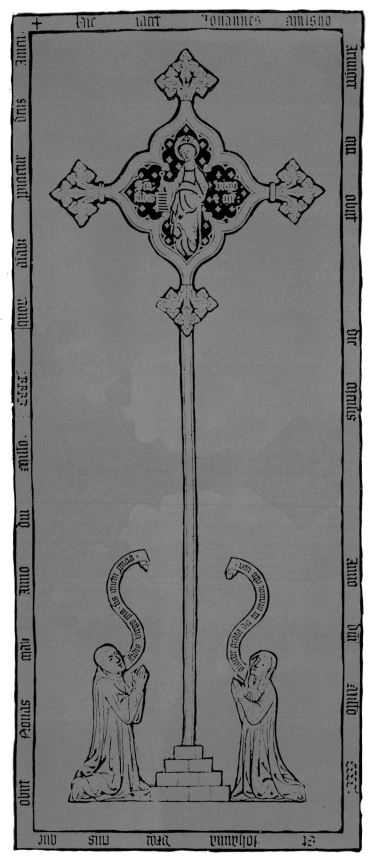

93. John Mulsho and wife Joan 1400, Newton-by-Geddington, North-ants. St Faith appears in the head of the cross with her implement of martyrdom and a bedstead and little crosses. Prayer labels issue from John and Joan. Rectangle – 5 ft. 9 in. deep.

92. Thomas Burgoyn 1516, Sutton, Beds. A simple, effective design. The inscription has a semi-italic slant. 22 in. wide.

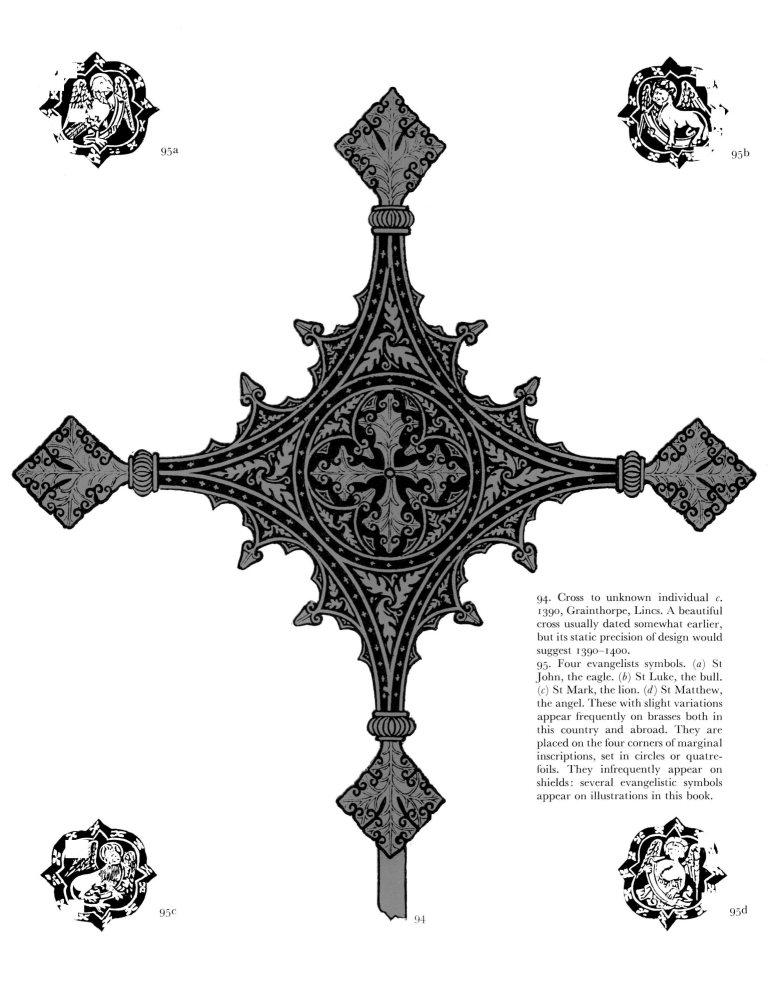

95a

95b

95c

94. Cross to unknown individual *c.* 1390, Grainthorpe, Lincs. A beautiful cross usually dated somewhat earlier, but its static precision of design would suggest 1390–1400.

95. Four evangelists symbols. (*a*) St John, the eagle. (*b*) St Luke, the bull. (*c*) St Mark, the lion. (*d*) St Matthew, the angel. These with slight variations appear frequently on brasses both in this country and abroad. They are placed on the four corners of marginal inscriptions, set in circles or quatrefoils. They infrequently appear on shields: several evangelistic symbols appear on illustrations in this book.

94

95d

96. Devil-bird from the brass of Bishops Bouchard and John Von Mul 1317–50, Lübeck.

97. Dragon from the brass of John Luneborch 1474, Lübeck (see fig. 204). Numerous devices appear on brasses. This was common practice by Gothic craftsmen, not only on brasses but in numerous crafts when and where their fancy took them.

98. Detail from the brass of Thomas Magnus M.A. 1550, Sessay, N.R. Yorks.

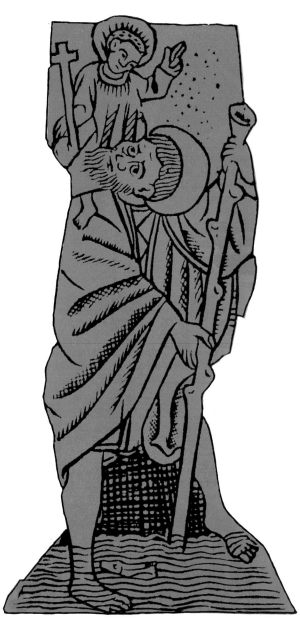

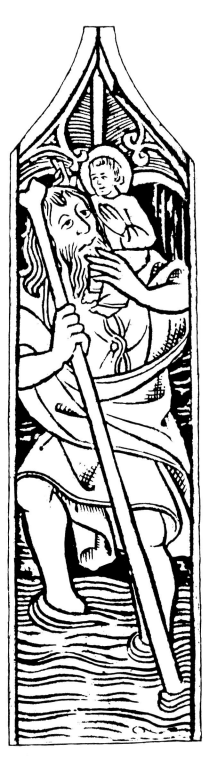

99. St Christopher on brass of William Complyn 1498, Weeke, Hants. 8½ in. deep.

100. St Christopher on brass of Ralph Tattershall c. 1470, Tattershall, Lincs. 14 in. deep. These two effigies show different interpretations of the same subject. The Weeke brass has the appearance of being the earlier by two or three decades, whereas in fact it is nearly thirty years later.

101. John Killingworth 1412, Eddlesborough, Bucks. The only rose brass now existing. Another was known in Oxford but is now lost. The Killingworth inscription appears on fig. 221. 21 in. deep.

102. Merchant's mark of Thomas Pownder 1525, St Mary Quay, Ipswich, Ipswich Museum.

105. Merchant's mark of Laurence Pygot, woolman 1450, Dunstable, Beds. An excellent design. Most of these merchants' marks are of the same high standard.

109. Shield of arms of Thomas Gifford 1550, Twyford, Bucks. Size 6½ in. deep.

103. Merchant's mark from the brass of Thomas Bushe, woolman 1525, Northleach, Glos. Arms of the Staple of Calais also on brass. Size 6 in. deep.

106. Arms of the Staple of Calais on the brass of John Feld 1474, Standon, Herts. This appears on numerous brasses.

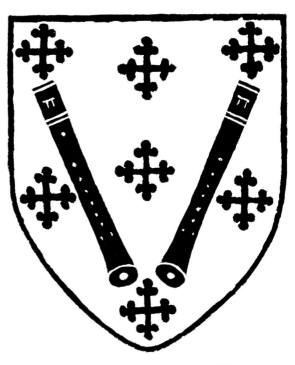

110. Shield from the brass of Sir William Vernon 1467, Tong, Salop. Use of a woodwind instrument on heraldic shield (fig. 32).

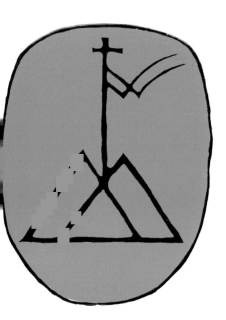

104. Merchant's mark on brass of William Midwinter 1501, Northleach, Glos. William and his wife each rest their feet on a sheep. Size 4 in. deep.

107. Arms of Merchant Adventurers on the brass of Andrew Evyngar 1533, All Hallows, Barking, Essex.

108. A rebus on the brass of Richard Colwell 1533, Faversham, Kent. An amusing symbol.

111. Detail on brass of John Taylour 1490, Northleach, Glos. The sheep standing on a woolpack with crooks denote yet another wool merchant in this church of St Peter and St Paul.

114. Shield showing Merchant Tailors arms on brass of Robert Coulthirst 1631, Kirkleatham, Yorks. Died aged 90.

112. Curious detail from the helm of the brass of Sir Nicholas Dagworth 1401, Blickling, Norfolk (see fig. 21).

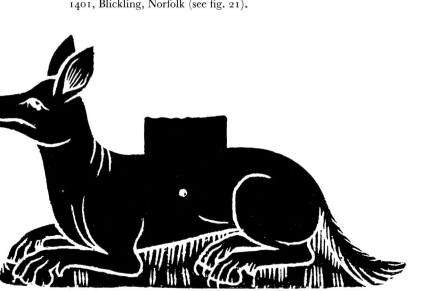

113. Detail from the base of bracket brass – Sir John Foxley 1378, Bray, Berks. The fox also appears in the helm of Sir John.

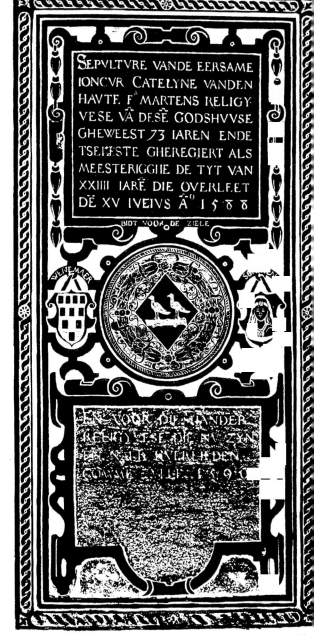

115. This illustrates the use of stone and brass on the same memorial. Catelyne Van Den Haute 1588, Ghent. The lozenge in the middle shows Cate-lyne's mark or armorial bearings.

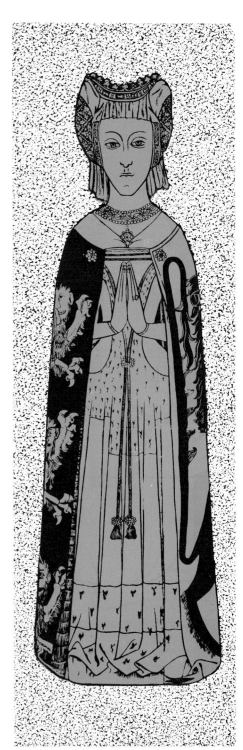

116. Lady Maud Foxley 1378, Bray, Berks. Sir John's first wife, who wears a heraldic dress and the nebule head-dress. Effigy 29 in. deep.

117. Lady Joan Foxley 1378, Bray, Berks. Sir John's second wife, who also wears a heraldic dress and nebule head-dress. Effigy 29 in. deep.

118. Lady Joyce Tiptoft c. 1470, Enfield, Middx. She wears the heraldic mantle and coronet. She died in 1446, the brass engraved later. Effigy 54 in. deep.

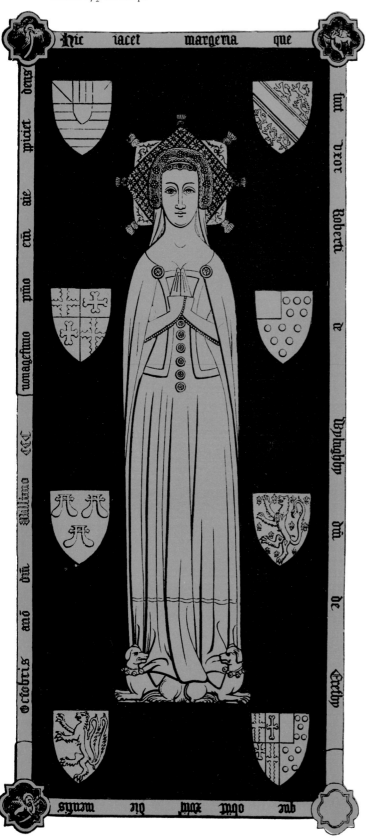

119. Lady Margery D'Eresby 1391, Spilsbury, Lincs. A brass typical of its date, the execution is superb, the design though somewhat mechanical is good. Composition 67½ in. deep.

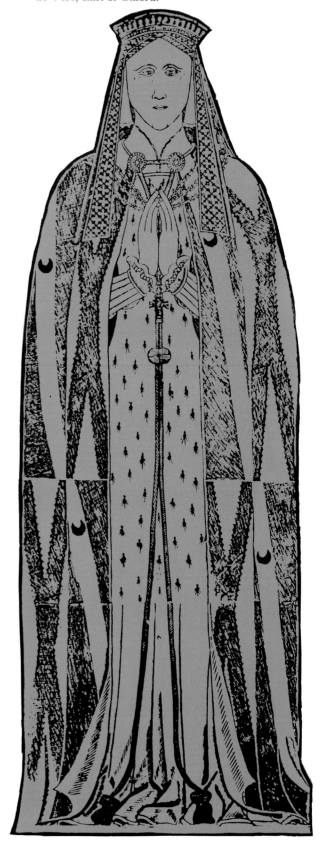

120. Elizabeth, Countess of Oxford 1537, Wivenhoe. She wears heraldic mantle, ermine cote-hardi and coronet. Widow of Lord Beaumont and wife of John de Vere, Earl of Oxford.

121. Sir Ralph and Lady Elizabeth Verney 1547, Aldbury, Herts. Sir Ralph in armour and heraldic tabard, Lady Elizabeth in heraldic mantle. A brass showing excellent heraldic display. The brass is well cut and still in good condition, but some shields are missing. Effigies 25 in. deep.

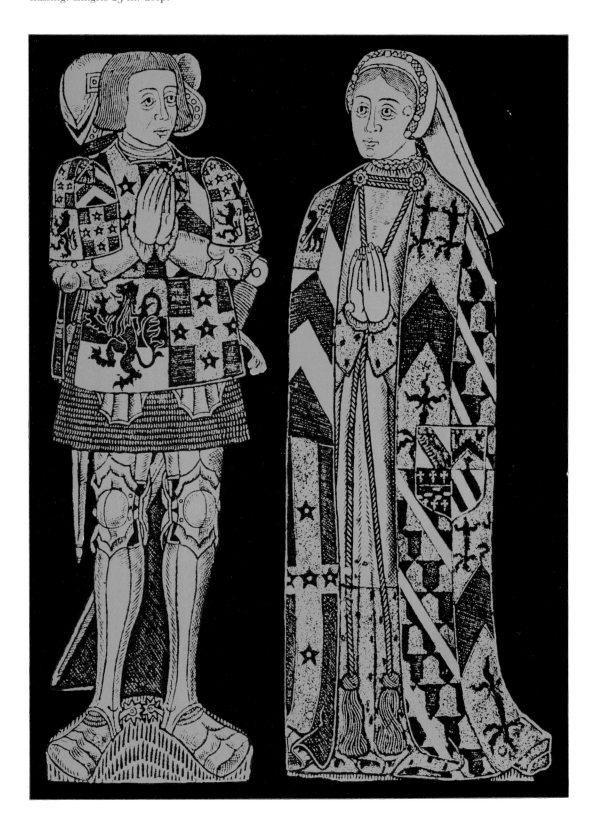

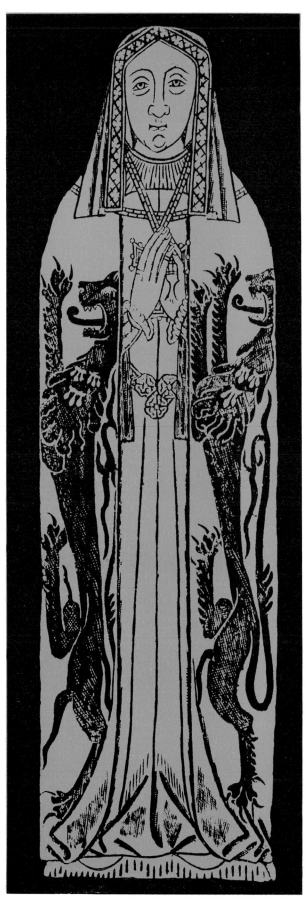

122

122. Unknown lady 1535, St Helens, Bishopsgate. In heraldic mantle. A bottle-shaped effigy. Depth 34 in.

122. Unknown lady 1535, St Helens, Bishopsgate. In heraldic mantle. A bottle-shaped effigy. Depth 34 in.

123. Lady Katherine Howard 1535, St Mary, Lambeth. In heraldic mantle. Like fig. 122, it is another bottle-shaped effigy – not a good arabesque, but both these brasses are attractive because of the fine display of heraldry. Lady Katherine's face is pretty, which considerably adds to the charm of the brass. Depth 38 in. Both ladies wear pedimental head-dresses.

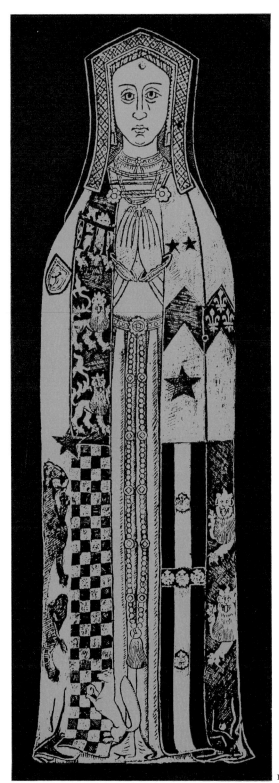

123

124. John Feld Sen. 1474, Standon, Herts. Alderman of London, merchant of the Staple of Calais. In civil dress and mantle. He is on an altar tomb with his son next to him (fig. 125) and two sons and one daughter below. John Feld jun. his son 1477 (fig. 125) in armour and tabard with two sons and two daughters below (see fig. 150). John jun. also shows the Staple and Merchant's mark. Both these brasses are unmistakable portraits. Both effigies 36 in. deep.

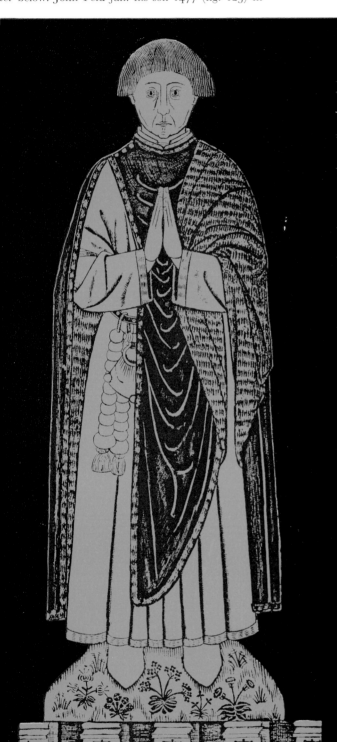

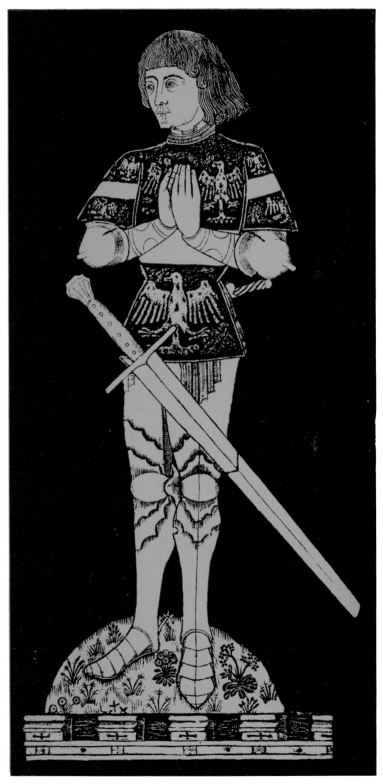

124

125

127. (*Opposite*) Dame Brygete Marney 1549, Little Horkesley, Essex. In heraldic mantle with two husbands. John Lord Marney and Thomas Fyndorne both in armour with tabards. Though each effigy is attractive there is no unity about the whole design. The inscription shields and effigies are placed without any consideration as to their relationships of a unified composition. All three must be portraits. Composition 44 in. deep.

126. Sir Edmond Tame and two wives 1534, Fairford, Glos. Agnes his first wife with one son and three daughters and Elizabeth the second wife. Both wear heraldic mantles. All kneeling at faulstools. An attractive Trinity at the top. There are two brasses to this family in the Fairford Church: one shows only one son. The inscription is cut in relief. Composition 2 ft. 9½ in. deep.

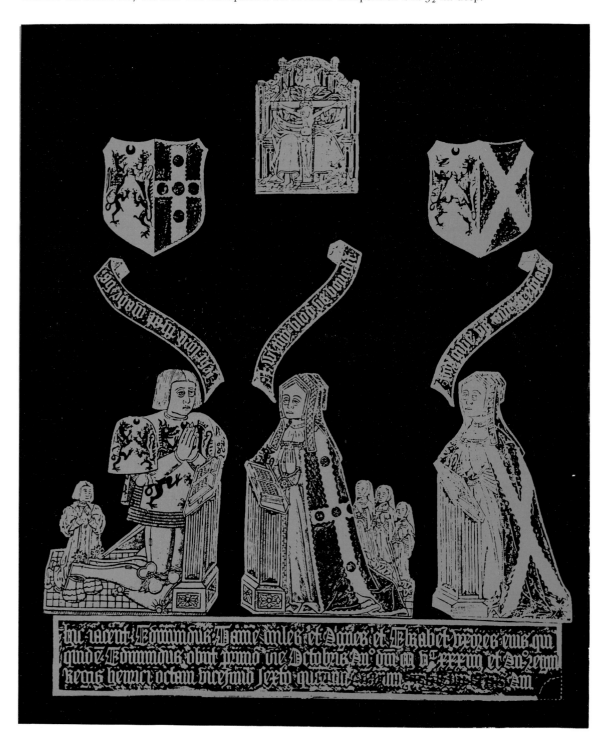

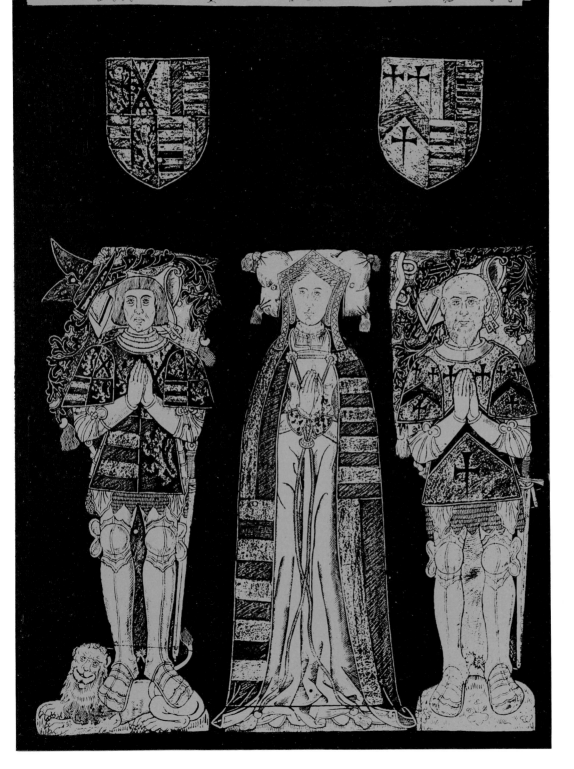

Here vnder lyethe Dame Brygete Marnay late the wyffe of John lorde
Marnay and sometyme wyffe to Mr Thomas ffyndone Esquyer and
deceyssyd the xxx day of September in the yere of our lorde God M cccc xlix

128

128. Sir Peter Legh 1527, Winwick, Lancs. A rare brass in that it shows a knight in armour wearing a chasuble and displays a shield of heraldic arms on his breast. He was brother-in-law to Thomas Savage, Archbishop of York.

129. John Goodwyn 1558, Upper Winchendon, Bucks. His wife Katherine bore him eighteen children. A fine heraldic display. The brass is in excellent condition – the execution first class, the inscription excellent. 27 × 17 in.

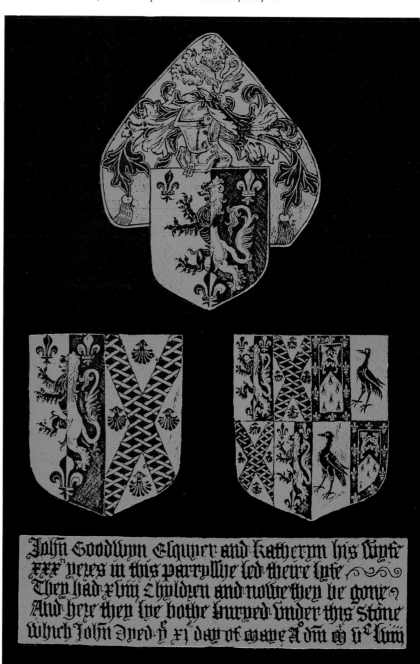

129

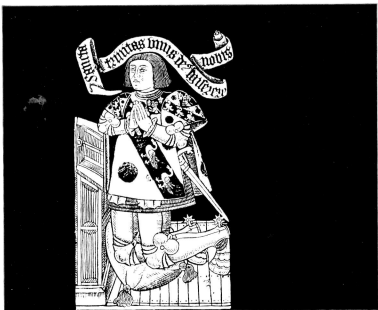

132

Here lyeth Sr Iohn Clerk of Northe Weston knyght wych toke
lowps of Orleans duk of longne uille & marqun of Rotelin
pryson at ye iorney of Bomy by Terouane ye xvi day of August in
the v yere of ye Reigne of ye noble & victoriis kyng henry ye viii
wych Iohn deresyd ye v day of Apll A dni 1539 whose soule god pdo

130

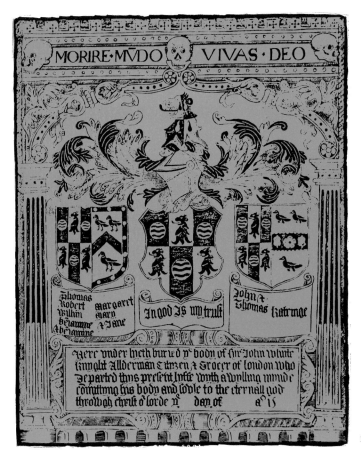

131

130. Sir John Clerk 1539, Thame,
Oxon. He wears heraldic tabard. A
lively design of great merit. The in-
scription in English is very interesting.
Size $18\frac{1}{4} \times 20$ in.

131. Sir John White 1573, Aldershot,
Hants. Alderman, citizen and grocer
of London. An overworked heraldic
quadrangular plate, cut with great
skill. Evidently it was made during
Sir John's lifetime; the date of his
death is left blank. Sir John's head
appears in the middle top of the design.
Size 22 in. \times 27 in.

132. Shield to Robert Washington
1622, Great Brington, Northants. The
Washington Arms, the origin of the
American stars and stripes. Arms:
Sable, two bars or three spur towels in
chief. The Washington family lived in
the same county. Size $5\frac{1}{2}$ in.

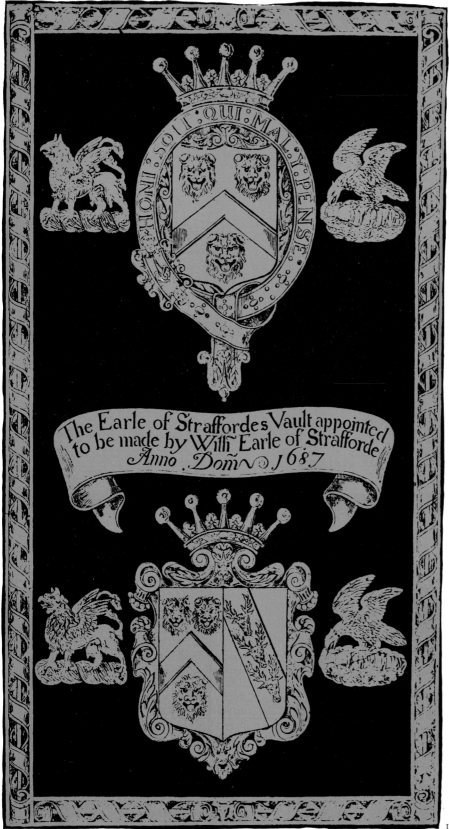

The Earle of Straffordes Vault appointed to be made by Willm Earle of Strafforde Anno. Dom 1687

133. Brass covering the vault of the Earl of Strafforde 1687, York Minster. A late seventeenth-century brass giving a fine heraldic display. 72 in. deep.

134. Two head-dresses from the two wives of Sir Reginald De Malyns 1385, Chinnor, Oxon. The demi-effigy on the left illustrates the nebule style and the right demi-effigy the zigzag style. Part illustrated 18 in. deep.

135. Joan Peryent 1415, Digswell, Herts. A symbolical portrait. A unique head-dress, Margaret wears an S.S. collar and swan brooch. This illustrates only part of brass which is full-length figure, next to her husband. Size of part illustrated 34 in. × 19 in.

136. Lady Laura, wife of Sir John de St Quintin 1397, Brandsburton, E.R. Yorks. A charming figure who is depicted with her husband on the brass (head lost). This figure is drawn with great skill and understanding of movement and form. Note the 'hook' technique in the drapery (see fig. 9a). A late fourteenth-century brass which has none of the mechanical outlook that entered the engraving of brasses about this time. Effigy 71 in. deep.

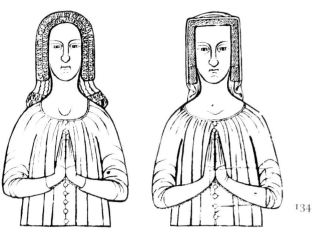

134

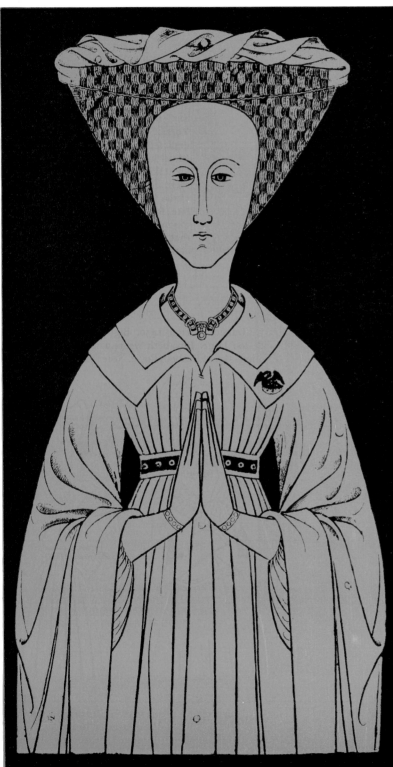

135

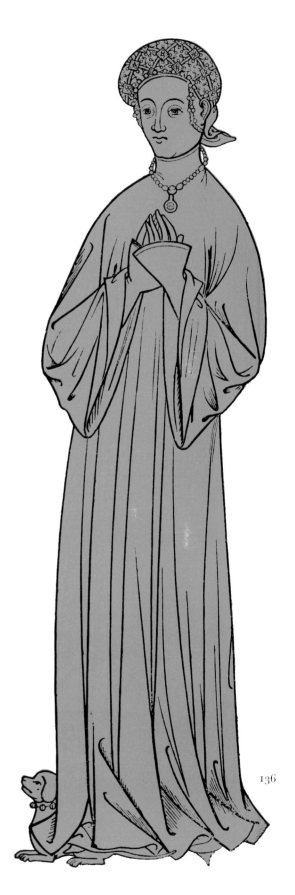

136

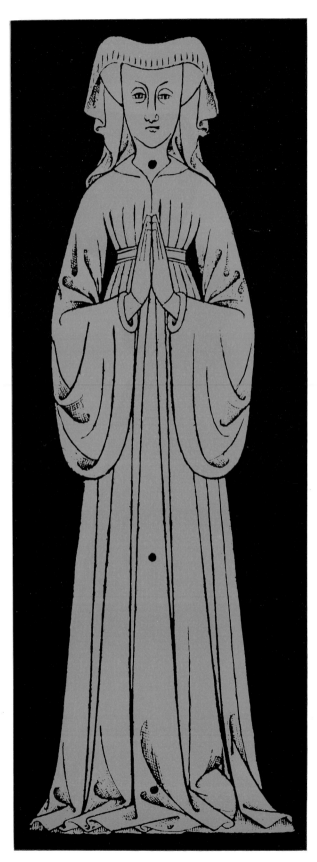

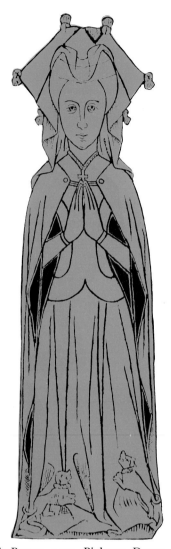

138. Elizabeth Burton 1450, Bigbury, Devon. Head and hands too large. Elizabeth wears a more pointed, horned headdress than Elizabeth Poyle. Note the two dogs at her feet.

137. Elizabeth Poyle 1424, Hampton Poyle, Oxon. Wife of John Poyle (see figs. 22, 193). An excellent, simple brass. She wears a horned head-dress. Effigy 24 in. deep.

139. (Left) Elizabeth Walrond (Roches) 1480, Childrey, Berks. She wears a variation of the mitre head-dress. (Part of brass only.) Her husband is illustrated in fig. 57.
(Right) Anne Gaynesford 1490, Checkendon, Oxon. She wears the bonnet-type head-dress (part of brass only).

140. Margaret Peyton 1484, Isleham, Cambs. A very attractive Italian brocade dress. The constant pattern is broken up to denote the folds by the perpendicular scoring lines. The action of the hands is found mostly on East Anglian brasses. Effigy 31 in. deep.

141. Margaret Dayrell 1491, Lillingstone Dayrell, Bucks. A very fine portrait brass – a very elegant lady with a most graceful movement giving dignity to her pose. Margaret wears a butterfly head-dress. Effigy 31 in. deep.

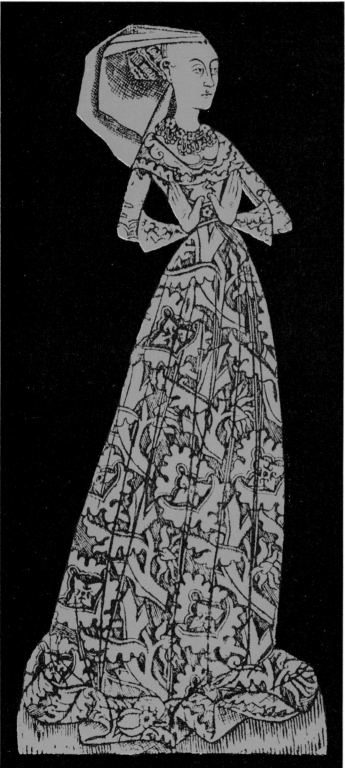

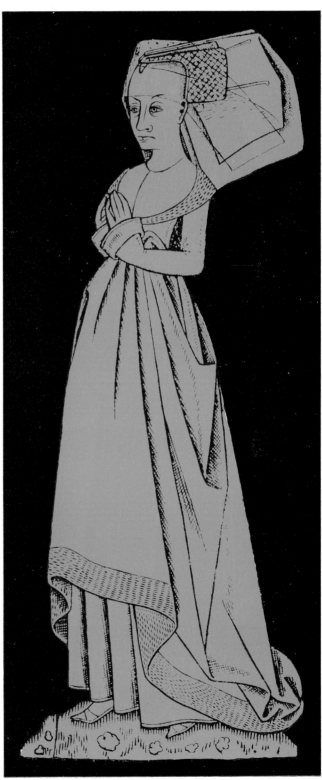

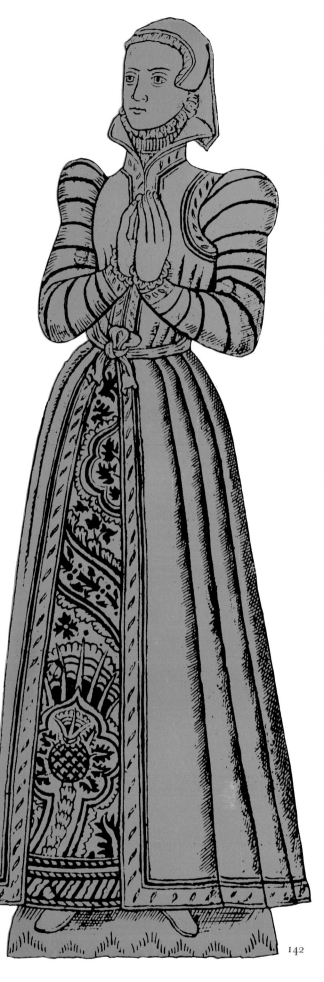

142. Alice Hyde 1567, Denchworth, Berks. A good brass. The figure has dignity. The open gown displays an elaborate pattern typical of the Elizabethan period. Alice's face shows a strong character likeness. Her husband is illustrated in fig. 35. Effigy 26 in. deep.

143. Isabel Cheyne 1485, Blickling, Norfolk. A lively figure. Isabel holds her hands in the East Anglian manner. Note her attractive necklace. Effigy 32 in. deep.

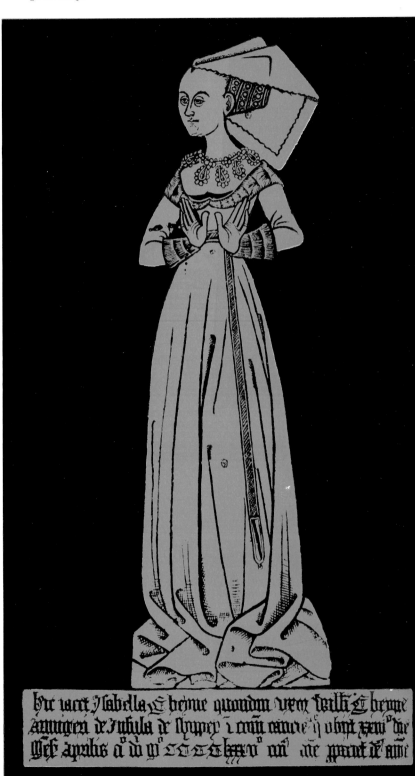

142

143

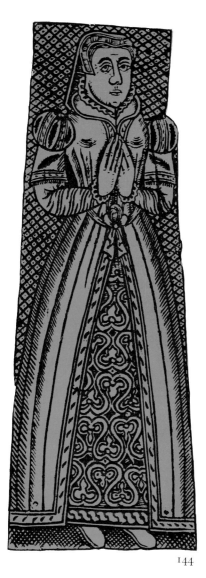

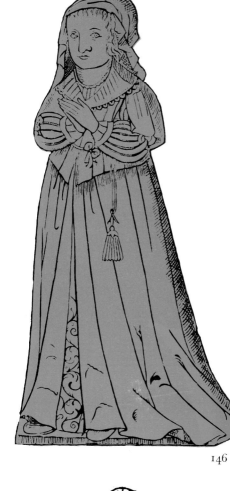

144

145

146

144. Lady Cecily Fortescue 1570, Mursley, Bucks. A very stylized figure. Effigy 14½ in. deep.

145. Colubery Mayne, widow 1628, Dinton, Bucks. A sketch-book brass and probably a good portrait. Effigy 19½ in. deep.

146. Elizabeth Culpepper 1634, Ardingly, Sussex. A charming sketch-book brass of a young girl. She died aged 7 years (see fig. 155, probably by the same craftsman).

147. Lady Margaret Harper 1573, Bedford. Wife of Sir William Harper (see fig. 40). Effigy 20 in. deep.

148. Elizabeth Broughton 1524, Chenies, Bucks. Spinster. A dumpy little figure, too short from the waist downwards. Note the flowing hair – the method of denoting a spinster.

147

148

149

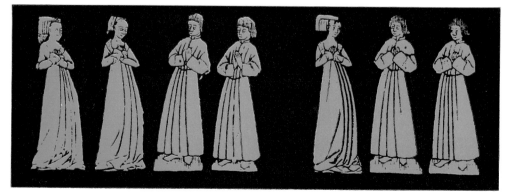

149. Elizabeth, Joan and Joan Tylney 1506, Leckhampstead, Bucks. An attractive trio, joined nicely together to form a good pattern. Their father was a citizen and alderman of London (see fig. 178). Effigies $7\frac{1}{4}$ in. deep.

150. The Feld children 1474–7, Standon, Herts. A very lively group put together with some considerable skill (see figs. 124–5 for their parents). Effigies $8\frac{1}{2}$ in. deep.

151. Joan Plessi *c.* 1360, Quainton, Bucks. A young woman drawn in a very simple manner. Reminiscent of the demi-effigy of Walter de Annefordhe 1361, Binfield, Berks. (see fig. 180). There is an inscription under Joan's head in Norman French. Size of part shown approx. 6 in. deep.

150

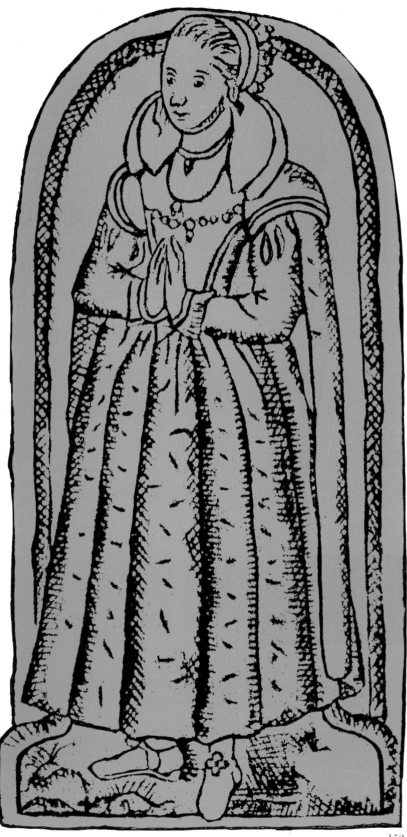

152

153

152. Elizabeth Chute 1627, Sonning,
Berks. A small sketch-book type of
brass of little skill, the inscription says
she died aged 3½ years, but the illu-
stration suggests that she was a fully
grown lady. Effigy 10 in. deep.

153. Dame Anne Norbury 1464, Stoke
D'Abernon, Surrey. She is a widow –
note the novel way of illustrating her
eight children.

154. John Stonor 1512, Wraysbury,
Bucks. A young schoolboy. The
Stonors lived at Stonor, Oxon., where
their descendents still live today
(1971).

John Kent 1434, Headbourne Worthy,
Hants. Another schoolboy – he studied
at Winchester. He is depicted in win-
ter clothes.

154

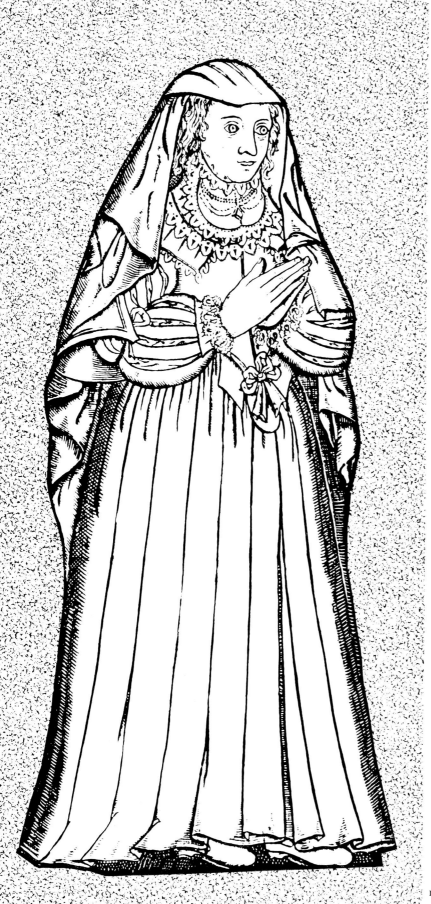

155. Lady Dorothy Mannock 1632, Stoke-by-Nayland, Suffolk. She was a widow of Sir Frances Mannock, with whom she lived twenty-four years, having four children. A good portrait brass.

156. William de Kestevne 1361, North Mimms, Herts. A less-accomplished brass than its near neighbour at St Albans (fig. 199). Doubtlessly made locally in the manner of the Continental series of similar effigies. It has distant characteristics with the effigy on its right. Composition 47 in. deep.

157. Sir Simon De Wensley (rector 1361–94), Wensley, Yorks. A chalice brass of Continental origin – Mosan. Very good craftsmanship, but the features and general forms are stylized. Note the convention used to denote the mouth. Effigy 64 in. deep.

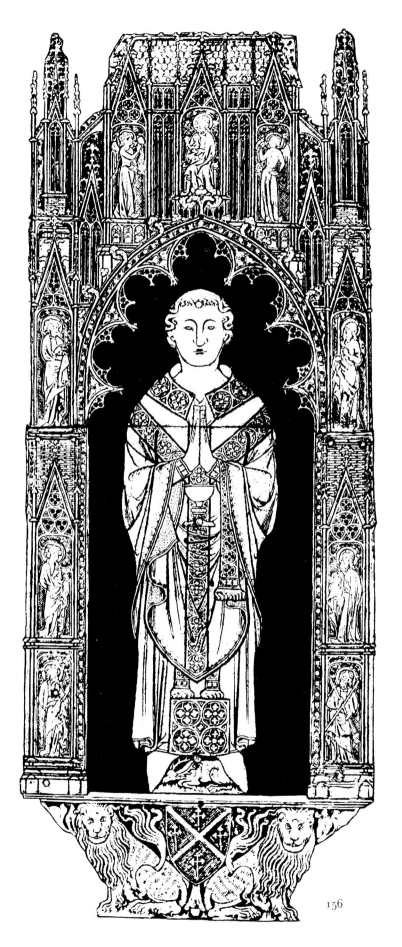

156

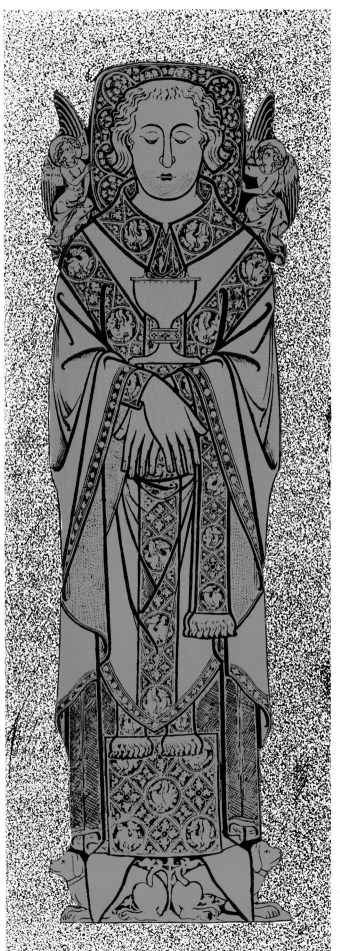

157

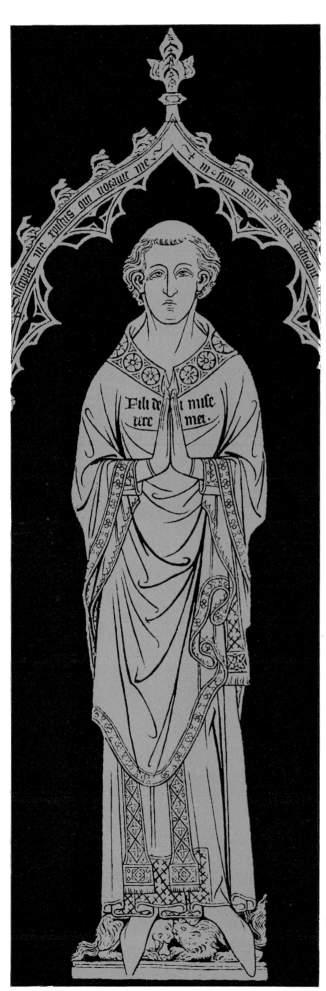

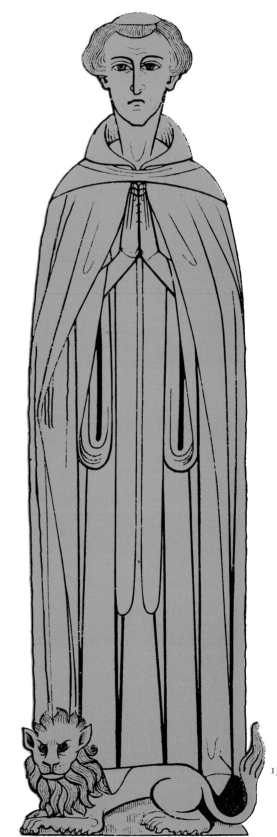

158. Laurence de St Maur 1337, Higham Ferrers, Northants. One of the best brasses to a priest, similar to the brass of Sir John D'Abernoun the younger (1327). Laurence has a graceful movement of the body. The drapery shows the hook technique (see fig. 9a). Effigy 63 in.

159. Unknown priest *c.* 1370 in choir cope. A clean simple brass of beautiful perpendicular lines. In spite of its simplicity there is a deep understanding in its linear construction. A portrait brass. Effigy 60 in. deep.

158

159

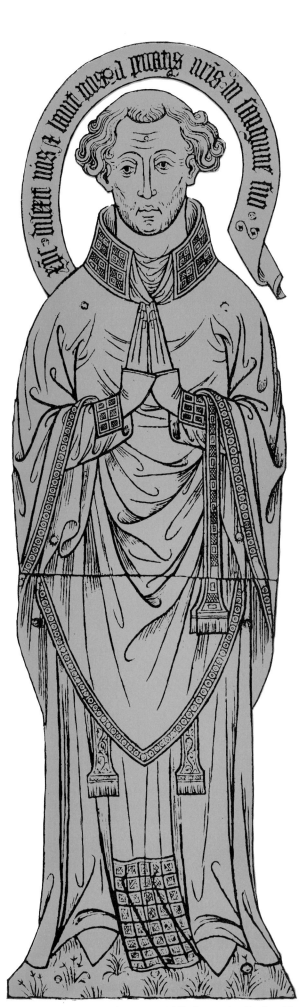

160. John de Swynstede 1395, Eddlesborough, Bucks. Note the hook technique. Effigy 51 in. deep.

161. Thomas Cranley 1417, New College, Oxford. Warden, Archbishop of Dublin. Effigy 58 in. deep.

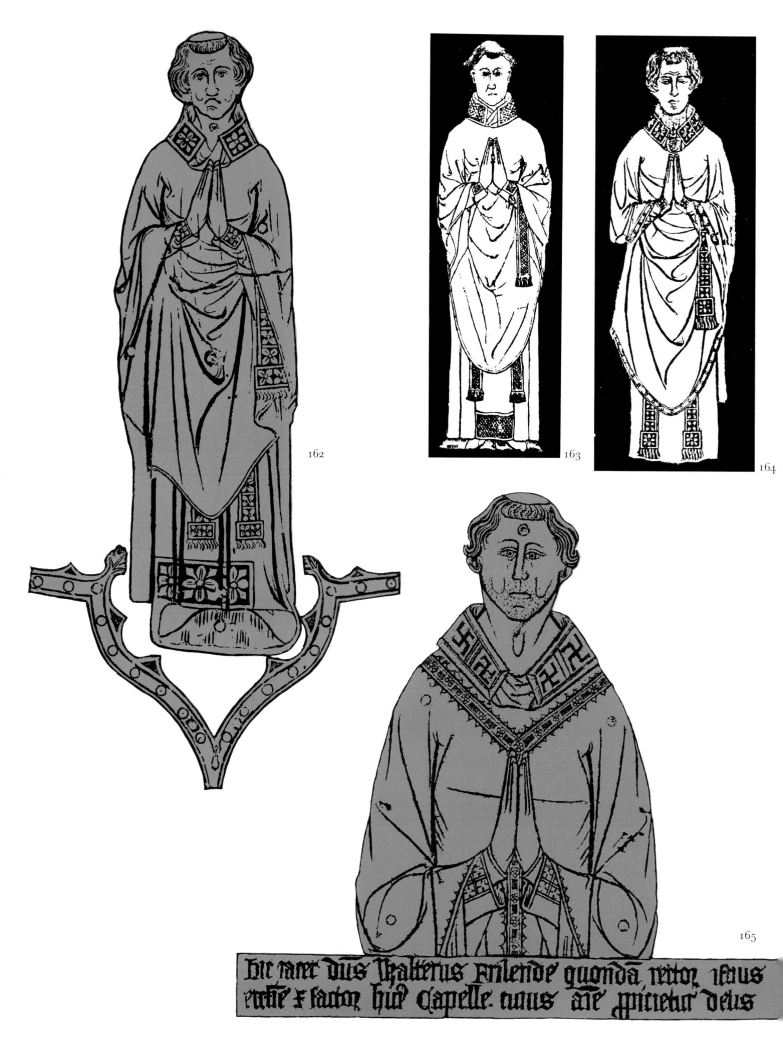

162

163

164

165

hic iacet dns Whalterus Frilende quonda rector istius
ecclie & factor huis Capelle cuius aie ppicietur deus

162. William de Herleston 1353, Sparsholt, Berks. A fine small effigy of a priest in a head of a cross (mutilated). Note the graceful movement of figure and drapery. Effigy 24 in. deep.

163. Unknown priest in Mass vestments *c.* 1480, Childrey, Berks. Effigy 34 in. deep.

164. John Seys, priest *c.* 1370, West Hanney, Berks. In Mass vestments.

165. Walter de Frilende, rector 1376, Ockham, Surrey. A fine brass full of character. The shape of the hands of folds of the vestments are fitted together in a remarkable manner. Effigy 18½ in. deep. The four priests on this page are character portraits.

166. Richard Bewfforeste, Augustinian Abbot of Dorchester 1510. He wears surplice, almuce and mantle with crosier, scroll inscription (damaged) restored in illustration. A good brass, the abstract qualities obtained from the drawing of the hands and vestments resolve themselves into an excellent pattern. Composition 50 in. × 17 in. Dorchester, Oxon.

167. James Stanley 1515, Bishop of Ely: Manchester Cathedral. A good portrait brass, but though near date of Bewfforeste it falls a long way short for beauty of design.

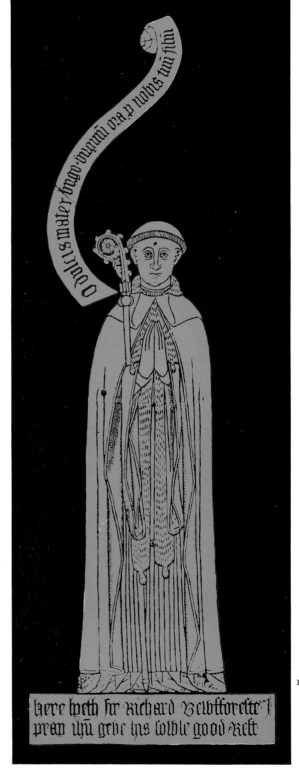

166

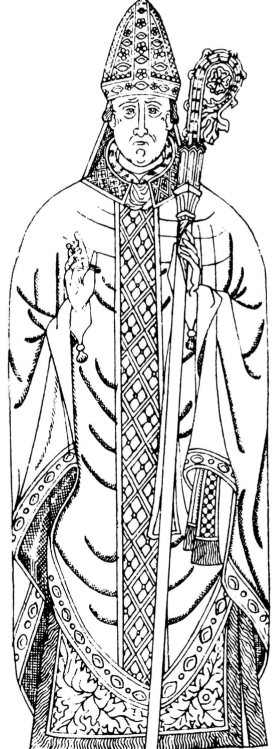

167

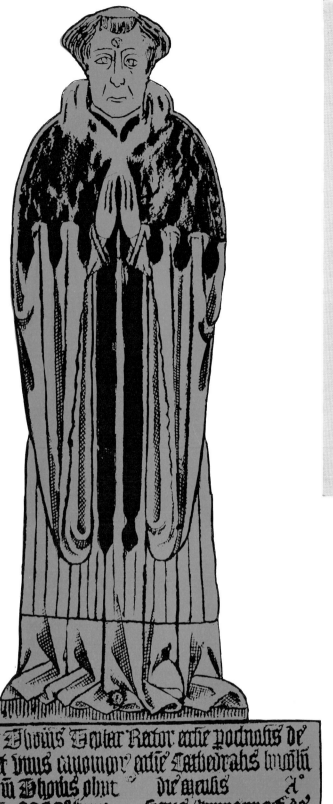

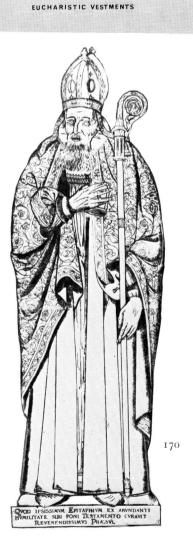

EUCHARISTIC VESTMENTS

Jewelled Mitre
Amice & Apparels
Orphrey
Episcopal Ring
Pallium
Chasuble
Crozier
Jewelled Glove
Maniple
Dalmatic
Tunicle
Stole
Alb
Orphrey of Alb
Sandle

169

168

168. Thomas Teylar, canon of Lincoln (1455–89) 1480, Byfleet, Surrey. He wears the almuce. The brass was cut in his lifetime; the date of his death shows a blank on the inscription. Depth including inscription 27½ in. A portrait brass.

170

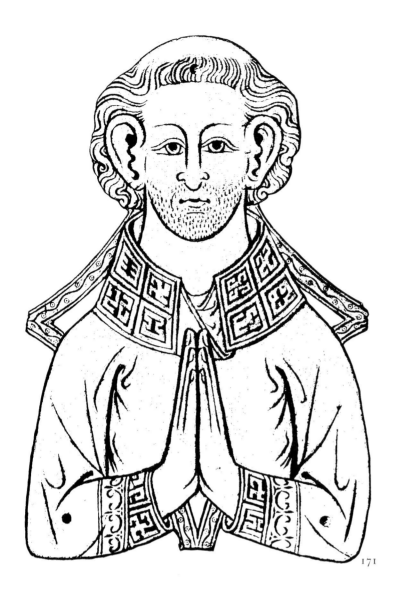

171

173

172

169. Illustration of an archbishop in Eucharistic vestments.

170. Samuel Harsnett, Archbishop of York 1631, Chigwell, Essex. He wears processional vestments and pastoral staff. A late example of a post-Reformation prelate wearing pre-Reformation vestments. A portrait but over-realistic.

171. Richard de Hakebourne 1311, Merton, Oxford. Demi-effigy in head of a cross. He wears Mass vestments. Note the interesting way the ears are symbolized. Size 21 in. deep.

172. Detail from the brass of Bishop Andreas 1479, Poznan, Poland. Lost in 1939–45 war. Shows gloves with insignia and rings worn over the gloves by bishops. The right hand is raised in blessing. Probably this brass was made in Poland or Lübeck.

173. James Coorthopp 1557, Christchurch, Oxford. Canon of Christchurch and Dean of Peterborough in almuce. Effigy 32 in.

176. (*opposite*) Geoffrey Kidwelly 1483, Little Wittenham, Berks. An enlargement of the head of fig. 54. An excellent portrait brass.

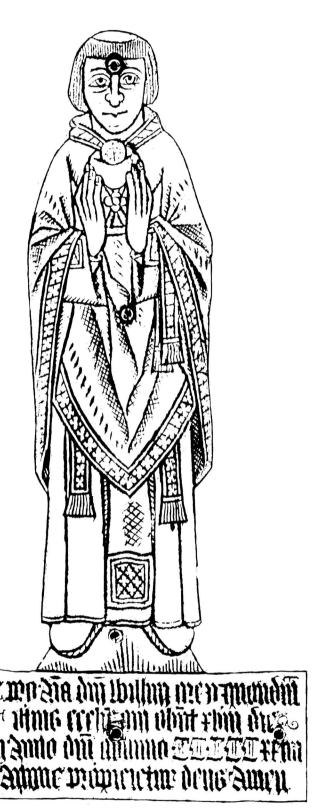

174. William Grey 1524, Eversholt, Dorset. Vicar in Mass vestments with chalice and wafer. Effigy 18 in.

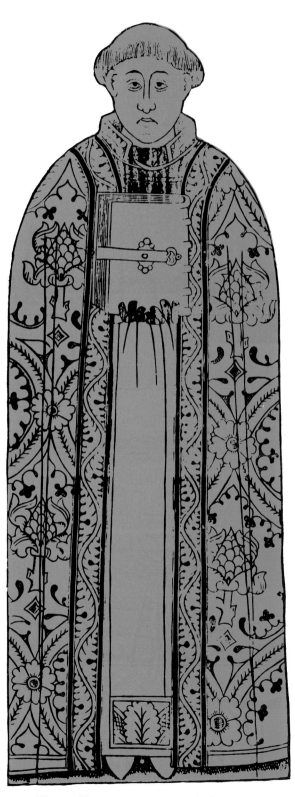

175. Thomas Tonge L.L.B. 1472, Beeford, E.R. Yorks. A bottle-shaped effigy. The diapered cope is decorated, which enriches the design. The method used to show the book (Bible?) held by the rector is good, because it completes the centre pattern of the design.

176

177. John Holtham 1361, Chinnor, Oxon. Provost of Queen's College, Oxford. A good demi-effigy full of character – an undoubted portrait. Effigy 24 in.

178. Regenolde Tylney 1506, Leckhampstead, Bucks. Citizen and alderman of London. A portrait. His children appear on fig. 149 (part of same brass). Effigy $5\frac{1}{2}$ in. deep.

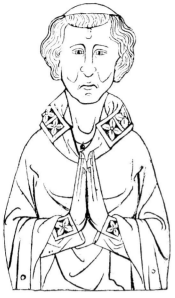

179. Unknown priest *c.* 1360, Wantage, Berks. Effigy 23 in.

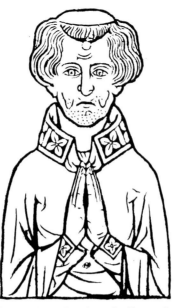

180. Walter De Annefordhe 1361, Binfield, Berks. Rector. Effigy 12 in.

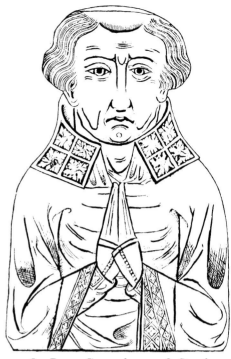

181. Roger Campedene 1398, Standford in the Vale, Berks. Effigy 28 in.

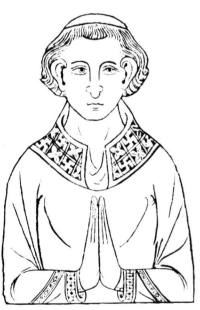

182. Thomas de Hope 1346, Kemsing, Kent. Priest. Effigy 21 in.

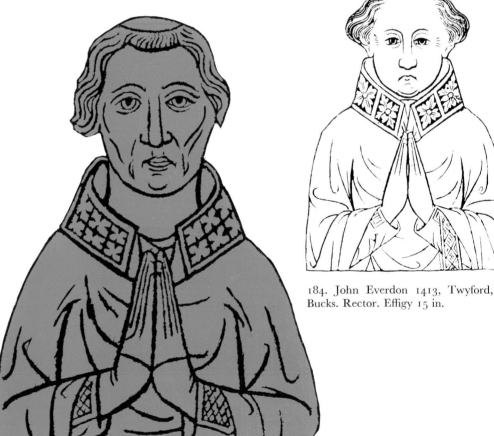

184. John Everdon 1413, Twyford, Bucks. Rector. Effigy 15 in.

183. Thomas Byrdde 1406, Berkhampstead, Herts. Rector. Effigy 12 in.

There could well be over two hundred demi-effigy portraits of ecclesiastics. This number could be doubled if certain full-length effigies of ecclesiastics and civilians, including demi-effigies of the latter, were included. By the late fifteenth century the portrait of the ecclesiastic almost disappeared.

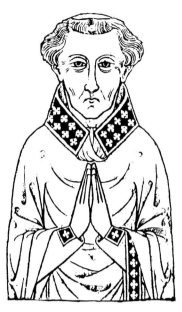

185. William Carbrok *c.* 1435, Wil-
hamstead, Beds. Chaplain.

186. William Lye 1391, Northfleet,
Kent. Rector.

187. William Branwhait 1498, Ew-
elme, Oxon. Master of hospital. Effigy
12½ in.

188. Sir Richard Catesby 1553, Ashby
St Legers, Northants.

189. John Tedcastell 1596, Barking,
Essex. Detail of brass.

190. Brother William Ternemu *c.* 1440,
Great Yarmouth. (A palimpsest.) On
the reverse is Alice Swane 1546,
Halvergate, Norfolk.

192. Marten Ferrades 1373, Madrid, Spain, often wrongly described as Flemish. It is clear that the angels on either side of the head are not by the same artist-craftsman who drew the head of Marten. A very stylized portrait. Notice the symbol used to denote the mouth. See figs. 156, 157, 198, 199, 200 and 228. In the church at Worfield, Salop, is a male head in a coloured glass window. The mouth is identical to the symbol used in the above brass. It is dated *c.* 1330. The glass is not Flemish.

193. John Poyle 1424, Hampton Poyle, Oxon. Detail of brass. See figs. 22 and 137. A more human face than fig. 192 which shows a cold, precise skill in its rendering.

191. Lady Margaret Bagot 1407, Baginton, Warwicks. Detail from large brass of Sir William Bagot and wife. (Part illustrated 21 in. deep.) This brass was restored in the nineteenth century and coloured enamels incorporated into the design. There are incised slabs with effigies to the Bagot family of 16th and 17th century date at Blithefield, Staffordshire. Though historically interesting, the Bagot brass is not of high character, as are many early fifteenth-century brasses. There is no reason to think that this is a portrait brass.

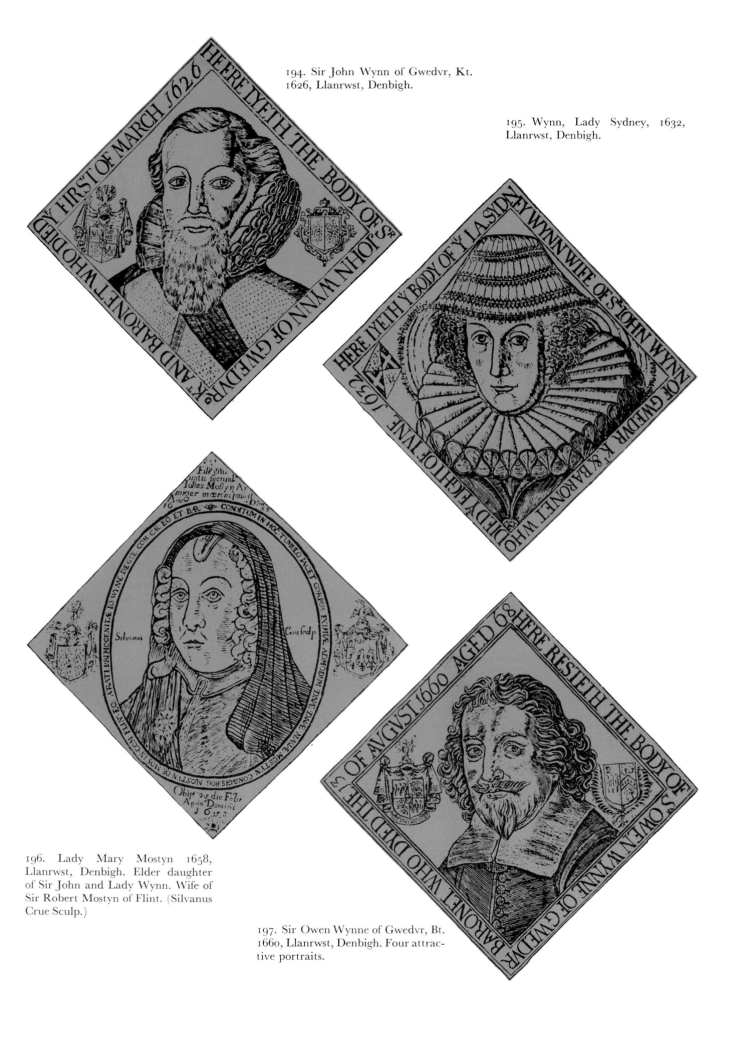

194. Sir John Wynn of Gwedvr, Kt. 1626, Llanrwst, Denbigh.

195. Wynn, Lady Sydney, 1632, Llanrwst, Denbigh.

196. Lady Mary Mostyn 1658, Llanrwst, Denbigh. Elder daughter of Sir John and Lady Wynn. Wife of Sir Robert Mostyn of Flint. (Silvanus Crue Sculp.)

197. Sir Owen Wynne of Gwedvr, Bt. 1660, Llanrwst, Denbigh. Four attractive portraits.

198. Bishops Godfrey and Frederic De Bulowe 1314–75, Schwerin, East Germany. The largest existing brass 151 × 76 in. A superb example of late fourteenth-century craftsmanship, 'full of craft but lacking in art'. Probably designed by Mosan craftsmen.

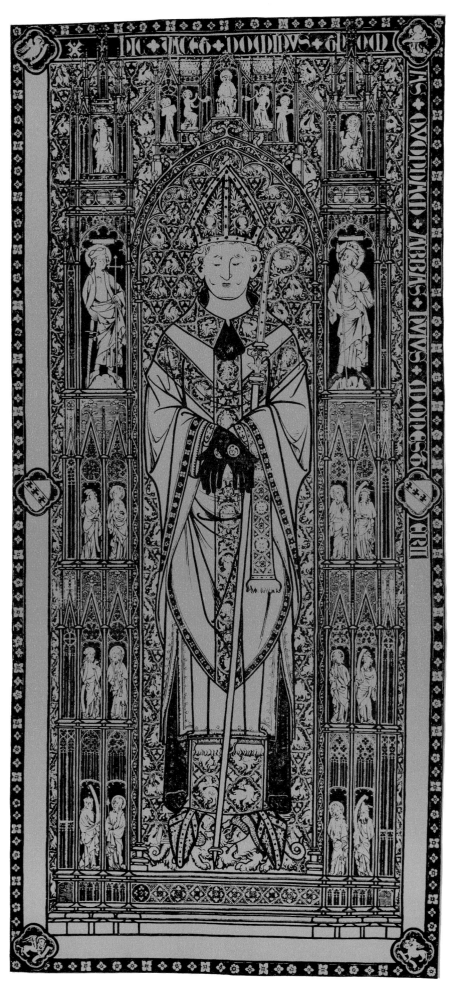

199. Thomas De La Mere 1349–96. Abbot St Alban's Cathedral, Herts. Engraved about 1370. Similar in outlook to fig. 198, but has not the same excellence of craftsmanship. Probably English derivative taken from the Mosan workshops, as also fig. 156, which shows still less skill. 112 × 52 in. NOTE. I have read that the contract for this brass exists, but exhaustive inquiries have failed to trace it. H.T.

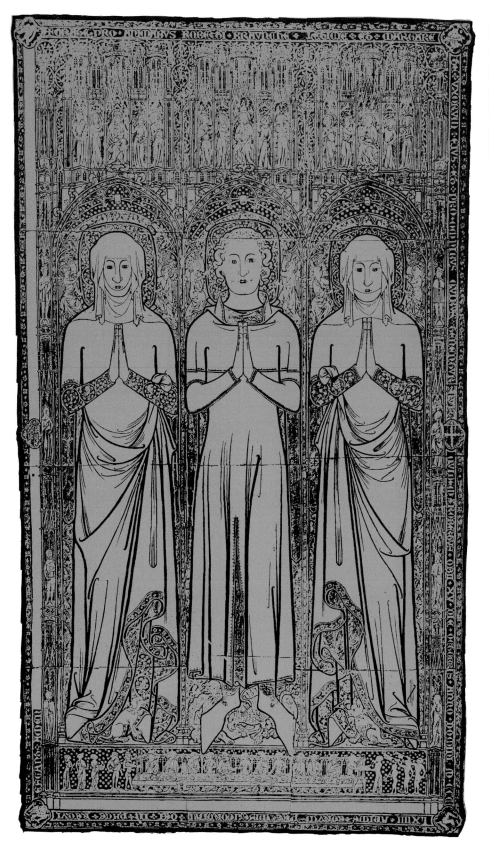

200. (*left*) Robert Braunche 1364 and two wives – Letice and Margaret, King's Lynn, Norfolk. Yet another example of a large quadrangular brass full of excessive detail of superb craftsmanship, coldly considered but lacking in artistic and spiritual qualities. The detail at the bottom centre shows a peacock feast, supposed to give everlasting life. Usually quoted as Flemish work but most probably Mosan. Size 107 × 61 in.

201. (*right*) Kurfüst Ernst Von Sachsen (Duke of Saxony) 1486, Meissen, East Germany. Son of 'Friedrich the Good'. Designed by Peter Vischer. Size 101 × 56 in.

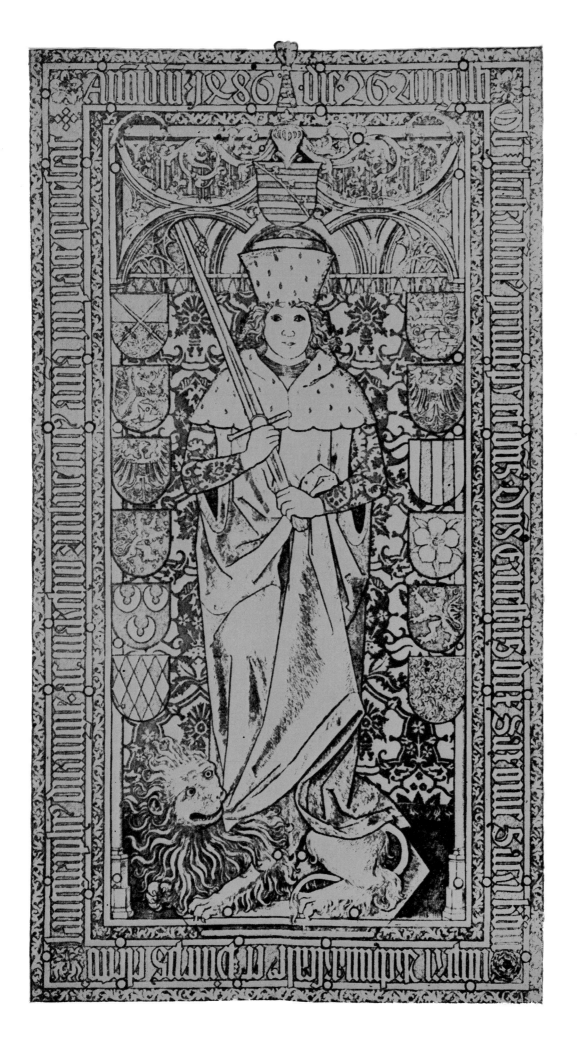

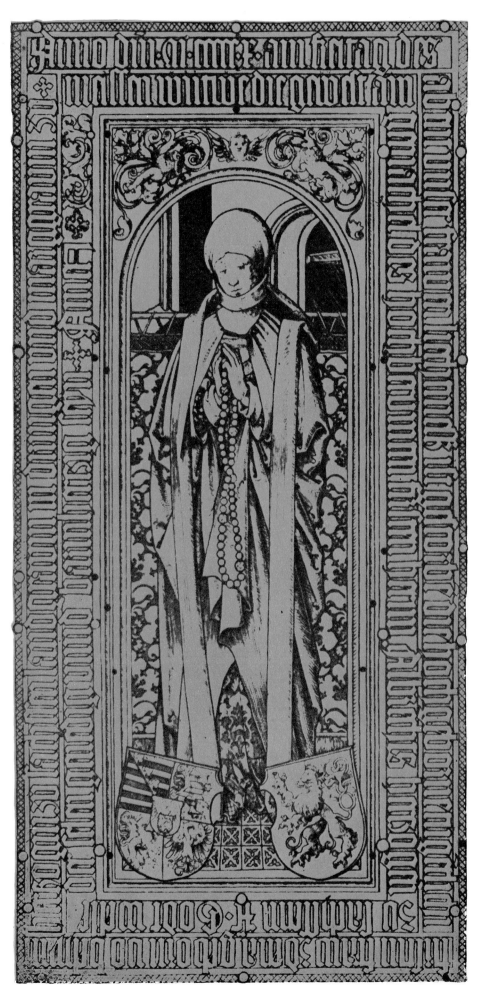

203. (*right*) Donna Branca de Vilhana *c.* 1500, Evora, Portugal. Wrongly called a Flemish brass. It is correct in Portuguese metalwork style of late fifteenth century. In 1955 an exhibition of Portuguese Art was held at the Royal Academy which included metalwork and paintings by Portuguese artist-craftsmen. This brass is too similar in design to be other than Portuguese. Size 75 × 44 in.

202. (*left*) Herzögin Sidonien (Duchess of Saxony) 1510, Meissen, East Germany. Sister-in-law to fig. 201. Designed by Peter Vischer. Size 95 × 48 in.

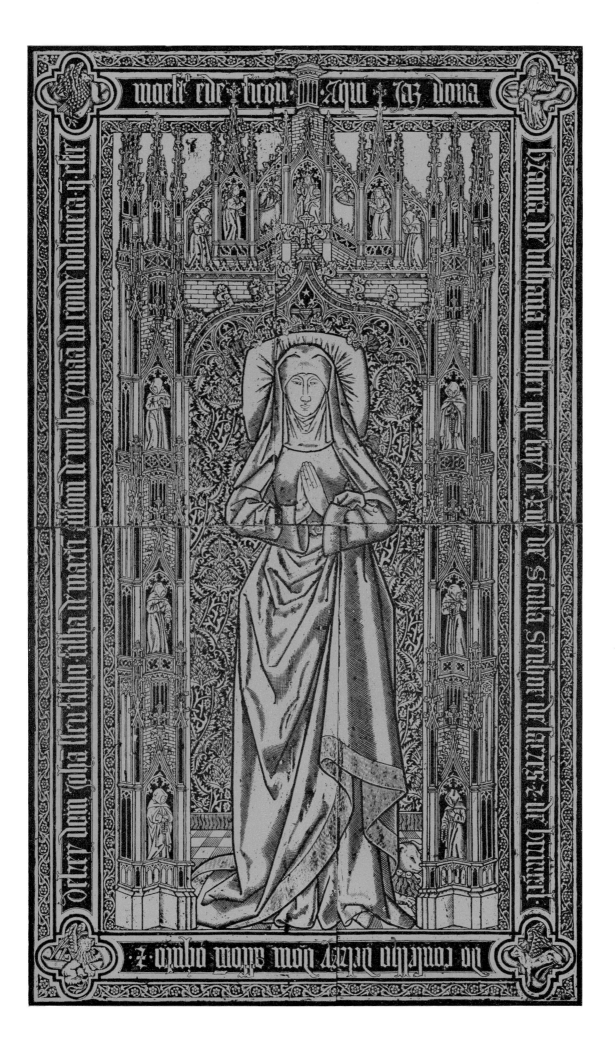

204

2

204. Johann Luneborch 1474, Lübeck. Mayor. A brass which illustrates the love of detail by the craftsmen of these large quadrangular memorials. They fall far short of the early English effigies, which are simple, have a beautiful movement and a refinement far in excess of these, hard, mechanical Teutonic creations. Probably made in a Lübeck workshop. A good portrait – not 'an attempt'. Size 111 × 60 in.

205. Jacques Pottier and wife Agnes 1604 and 1615. Templeuve, Tournai, Belgium. The illustration shows Jacques and Agnes kneeling to the crucifixion, supported by patron saints. The inscription records the foundation of masses. Size $42\frac{1}{2} \times 14\frac{1}{2}$ in.

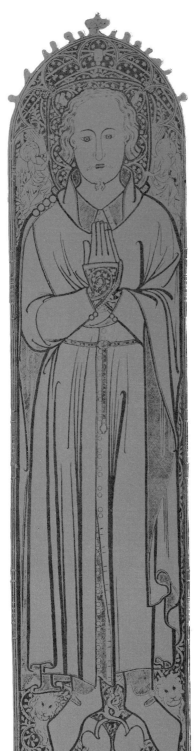

206. Herman Von Werthere 1395, Nordhausen Museum, East Germany. A local brass. The kneeling figure with his hunter's hat on the ground and the helm and crest with animal and shield also with animal suggest that Herman was a hunter or gamekeeper. This brass is reminiscent of German folk art – cuckoo clocks and pipes decorated with hunting scenes. There are four other brasses all the same size (25 × 19 in.) in the Nordhausen Museum. One is Herman's sister, who spells her name Verter.

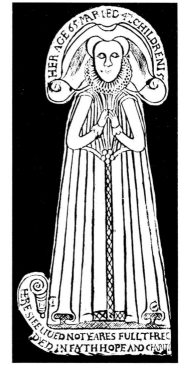

208. A lost brass, Robert Attelath burgess of King's Lynn, Norfolk, 1376. From a reversed impression taken by Craven Ord, now in the British Museum. Dated 13 September 1780. The effigy of Robert's wife was existing then but Craven Ord did not take an impression.

207. A West Country local brass *c.* 1630, Launceston, Cornwall. Unknown lady, died aged 65, married 47 years and bore five children.

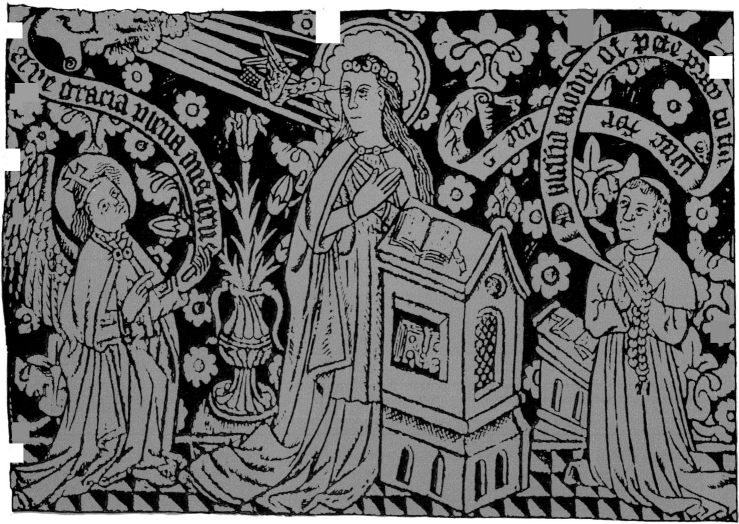

209. George Rede *c.* 1500, Fovant, Wilts. This brass was made during the rector's lifetime. He resigned in 1504. This book-illustration type of memorial brass depicts the Annunciation. The Blessed Virgin Mary in the centre: on her left is the Angel Gabriel; kneeling with a scroll inscription and on the right is the kneeling figure of the rector also with an inscription. A badly spaced inscription appears under the illustration. Size $15 \times 12\frac{1}{2}$ in.

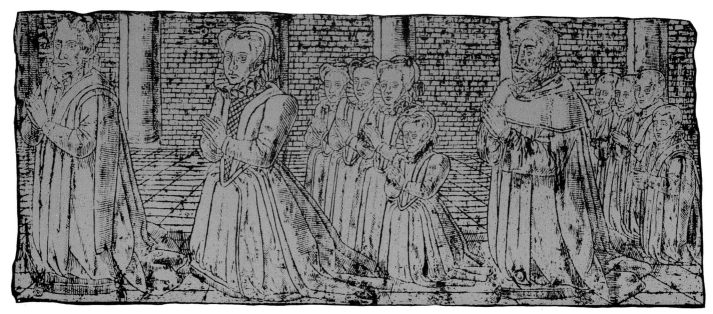

210. Joan Bradshaw and her two husbands 1598, Noke, Oxon. Her first husband was William Manwayringe and her second was Henry Bradshaw. This is a badly worn brass. There is an inscription under the illustration. Size $23 \times 8\frac{1}{2}$ in. William died in 1529 and Henry in 1553!

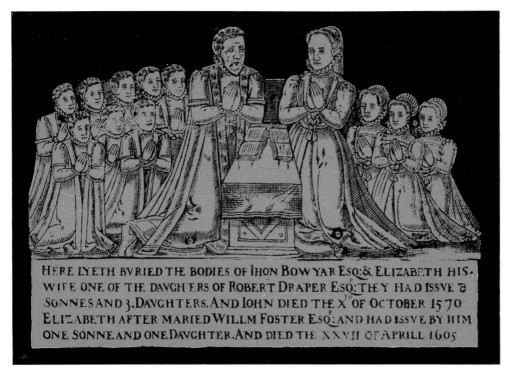

HERE LYETH BVRIED THE BODIES OF IHON BOWYAR ESQ:& ELIZABETH HIS.
WIFE ONE OF THE DAVGHERS OF ROBERT DRAPER ESQ:THEY HAD ISSVE 3
SONNES AND 3.DAVGHTERS.AND IOHN DIED THE X OF OCTOBER 1570
ELIZABETH AFTER MARIED WILLM FOSTER ESQ:AND HAD ISSVE BY HIM
ONE SONNE AND ONE DAVGHTER.AND DIED THE XXVII OF APRILL 1605

211. John Bowyer, wife and children 1570–1605, Camberwell, London. There are numerous brasses of this type of late sixteenth- and early seventeenth-century dates. The names of the individuals sometimes appear in scrolls above their heads. Size 22 × 18 in.

212. Anne Savage 1605, Wormington, Glos. A bedstead brass belonging to a small series of brasses to women who died in childbirth. Though not of special merit this brass is interesting in that it has good descriptive qualities, the perspective is good and the technique and design in the manner of seventeenth-century woodcut book illustrations. Size 22 × 21 in.

213. Geoffrey Fyche 1537, St Patrick's Cathedral, Dublin. Another brass in the manner of a book illustration. Geoffrey is kneeling to a representation of Our Lady in Pity. Size 24½ × 20 in.

214. Jane, Lady Bray 1539, Eaton-Bray, Beds. A brass of mixed merits. The figure and features
of Lady Jane are well drawn, but the heads of the children are too large for their bodies. The
perspective on the faulstool is bad, indicating that the brass is the product of dual craftsmanship.

216. (*right*) Anthonine Willebaert, died 1522, Bruges, Chapel of St Anthony. Brass engraved *c.* 1601, when her son-in-law died. An inscription underneath records the additional names and dates of the death of six near relatives. An attractive design spoilt by overcrowding and a decline in engraving. Depth of composition 29 in.

215. Bishop John Avantage 1456, Amiens, France. A derivative brass – influenced by Flemish, French and Italian fifteenth-century paintings. The bishop kneels in front of Virgin and Child with St John the Evangelist behind him. The long inscription is not very well spaced. Size 25 × 22 in.

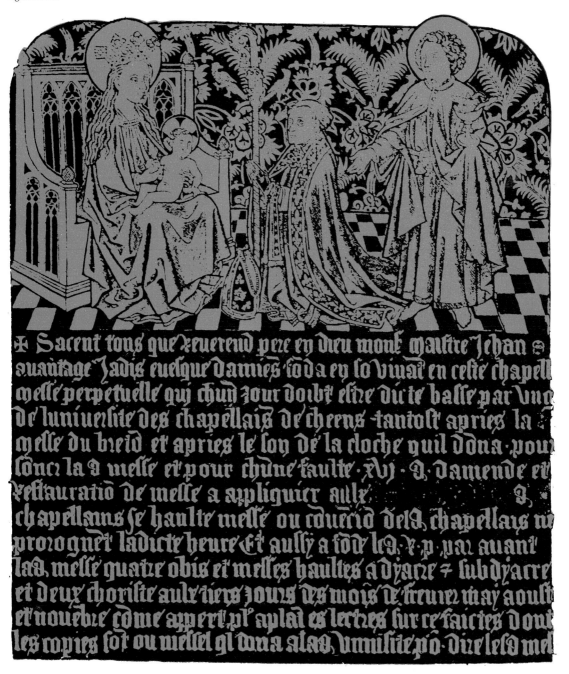

217

ANNO·AB·INCARNACIONE·ĐNI·M·CC·XLI
VIII·KEMAII·DEDICATA·EST·HEC·ECCIA
ET·HOC·ALTARE·CONSECRATVM·IN·HO
NORE·SCI·OSWALDI·REGIS·ET·MARTI
RIS·A·VENERABILI·PATRE·DOMINO·
HVGONE·DE·PATISHVL·COVENTRENSI
EPISCOPO.

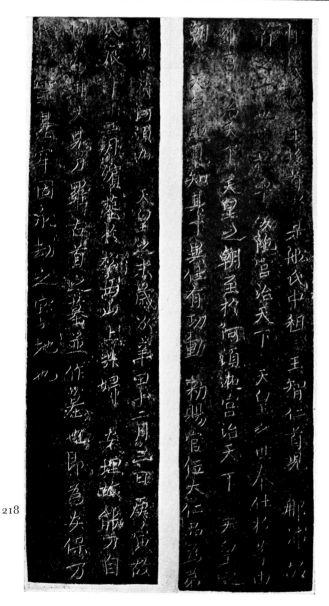

218

217. Ashbourne, Derbyshire 1241. Inscription and consecration of the church by Sir Hugh de Pateshull, Bishop of Coventry. The oldest brass inscription in the British Isles. $7 \times 3\frac{7}{8}$ in.

218. Rubbing of an ancient Japanese memorial inscription plate (copper), dated in correspondence with A.D. 668. The technique of making rubbings was known over 1000 years before Christ in both China and Japan. Portions of a book of rubbings A.D. 557–641 was found at Tun-huang. These ancient memorial plates were buried in the grave and are similar in text to our memorial inscriptions.

219. Brass consecration plate 1189, Regensburg, Germany. The earliest brass plate in Europe, records the consecration by Bishop Chunrad. Latin inscription in Lombardic gilded letters. $8\frac{1}{2} \times 6\frac{1}{2}$ in.

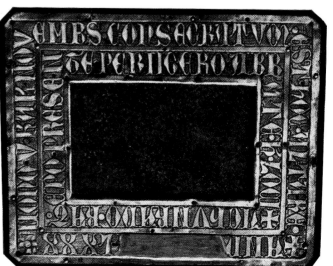

219

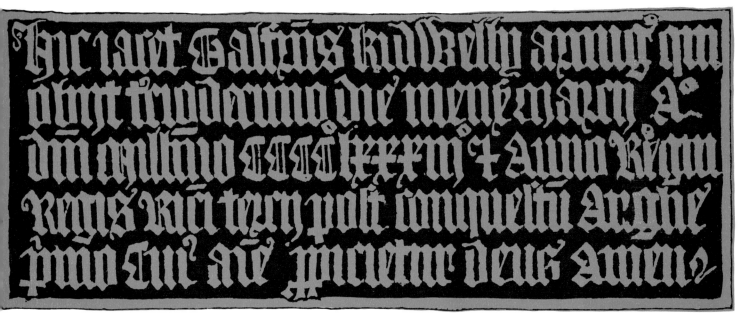

[Gothic script inscription]

220. John the Smith *c.* 1370, Brightwell Baldwin, Oxon. A very early inscription in curious English, recently restored. 21 in. wide.

[Gothic script inscription]

221. John Killingworth 1412, Eddlesborough, Bucks. This appears under the rose brass illustrated in fig. 102. It is a beautiful example of incised lettering. 20½ in. long.

[Gothic script inscription]

222. Geoffrey Kidwelly 1483, Little Wittenham, Berks. An example of raised lettering. This technique is not common on monumental brasses. 16 in. long (see figs. 54, 126).

223. William Shakespeare 1616, Stratford-on-Avon, Warwicks. An inscription of great historical interest in the church of Holy Trinity. At Stratford there is an engraved brass plate to Anne (Hathaway) 1623. She died aged 67.

IVDICIO PYLIVM GENIO SOCRATEM ARTE MARONEM
TERRA TEGIT POPVLVS MÆRET OLYMPVS HABET

STAY PASSENGER WHY GOEST THOV BY SO FAST
READ IF THOV CANST, WHOM ENVIOVS DEATH HATH PLAST
WITH IN THIS MONVMENT SHAKSPEARE: WITH WHOME
QVICK NATVRE DIDE: WHOSE NAME, DOTH DECK Y TOMBE
FAR MORE THEN COST: SIEH ALL Y HE HATH WRITT
LEAVES LIVING ART BVT PAGE, TO SERVE HIS WITT.
OBIT ANO DO 1616
ÆTATIS 53 DIE 23 AP

224. Chalice and wafer on a body, part of large fifteenth-century Continental brass. This appears on the reverse of the inscription to Nicholas West 1586, Marsworth, Bucks. Depth of part shown 13 in.

225 and 226. Parts of a large fifteenth-century Continental brass with part of symbol of St Luke and marginal inscriptions. Fig. 226 is made up of three pieces – all these appear on the reverse of the legs of Nicholas West. Five other pieces of the Continental brass are at Walkern, Herts. The fragment illustrated in fig. 225 is 18½ in. deep and that illustrated in fig. 226 is 11 in. deep.

227. Inscription in Norman French recording the foundation of Bisham Abbey, Berks. 1333. On the reverse side is an inscription to William Hyde 1557 and his wife Margery 1562, Denchworth, Berks. The Norman French inscription is as follows: *Edward, King of England, laid siege to the City of Berwick and conquered in battle the said city, the eve of St Margaret, the year of grace of 1333, laid this stone at the request of Sir William de Montagu, founder of this house.* Size 16½ in. long.

228

228 and 230. Dorothy Frankyshe 1574, Harrow, Middx. Two pieces of this brass (a) verses (b) inscription (not illustrated) are palimpsest. On the reverse of (a) appears the part of a brass illustrated in fig. 230. On the reverse of (b) appears the part of a brass illustrated in fig. 228. These two pieces do not belong to each other even though the decorations between the words are similar. They are fifteenth-century Continental.

230

229. Robert Pygott 1587 and wife Mary and children 1561, Waddesdon, Bucks. The small crucifixion (7½ in. deep) was discovered in 1967 on the back of part of Pygott brass. It is fifteenth century. The technique is unusual for a brass memorial plate. It may have been part of a bible cover or a church reliquary.

231 and 232. William Lord Zouch of Harringworth (died 1462) and two wives Alice died 1447 and Elizabeth who died after her husband. Okerover, Staffs. Brass 108 in. deep. Humphrey Oker, Okerover, Staffs. 1538 and wife Isabel and thirteen children. Humphrey's tabard came from Zouch's top piece of armour. The effigy of Alice Zouch was left for Isabel without alteration. The effigy of Elizabeth Zouch was reversed and the figures of Humphrey's thirteen children engraved as seen in the illustration. On the lower part of the head a shield was engraved. The shields were altered and additions made, the marginal inscription was reversed and engraved to fill in with Humphrey's requirements. In the middle of last century the brass was stolen and broken, but later recovered and reassembled.

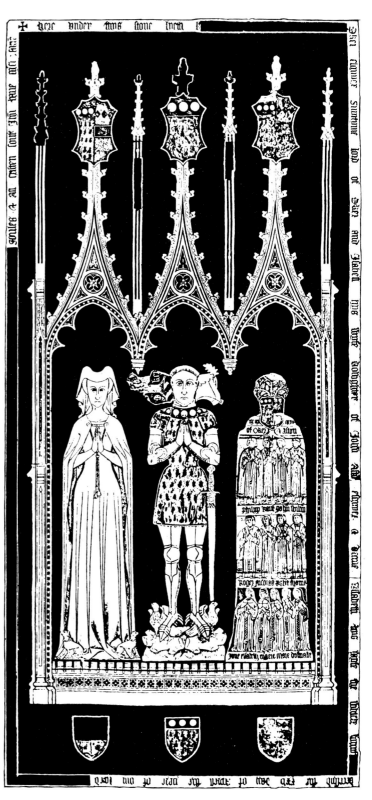

234. *(right)* Jane Gilbertson 1810, Llangynfelyn, Cardiganshire. A good example of an early nineteenth-century brass. The enamels (colours are used) are still in the incised areas, making it very difficult to obtain a good rubbing. Note the engraver's monogram at the bottom of the faulstool (Waller of London). Haines wrongly states that this brass is at Machynlleth. Size 36 × 29¾ in.

233. Lord Stowell 1836, Sonning, Berks. Friend of Dr Johnson and a great authority on maritime law. The mixing of different types of lettering with the coat of arms and decorations is most successful. The design is similar to that used on shop fronts, bill posters, stage coaches and the like in the early part of the nineteenth century. Size 28 × 24 in.

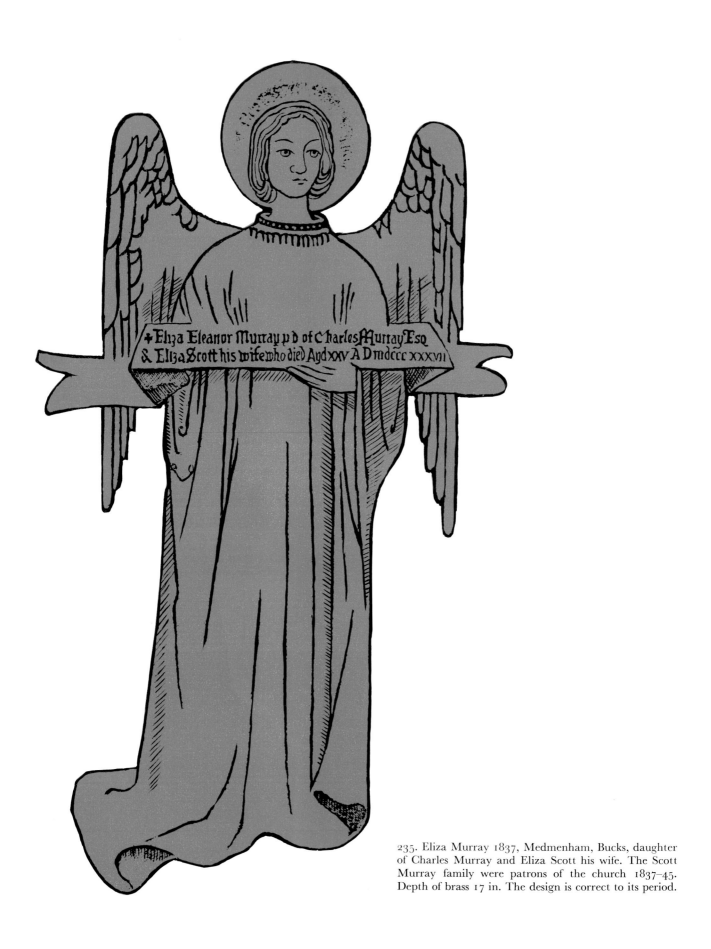

✠ Eliza Eleanor Murray p d of Charles Murray Esq
& Eliza Scott his wife who died Ayd xxv A D mdccc xxxvii

235. Eliza Murray 1837, Medmenham, Bucks, daughter of Charles Murray and Eliza Scott his wife. The Scott Murray family were patrons of the church 1837–45. Depth of brass 17 in. The design is correct to its period.

236

236. Frances Stubbs 1877. Died at Ramsgate and buried there. Memorial at Aylesbury, Bucks. A charming brass, the kneeling figure, the lilies, the decorations and lettering are correct to its period. Depth 30½ in.

237. Sophie Sheppard, 1848, Theale, Berks. She is depicted as a widow, died aged 80. The brass is on a canopy tomb – engraved by Hardmann. Depth 46 in.

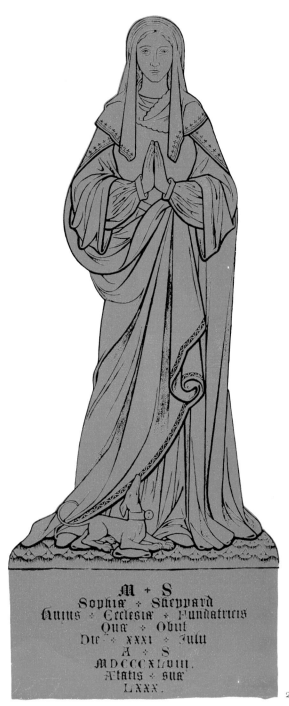

237

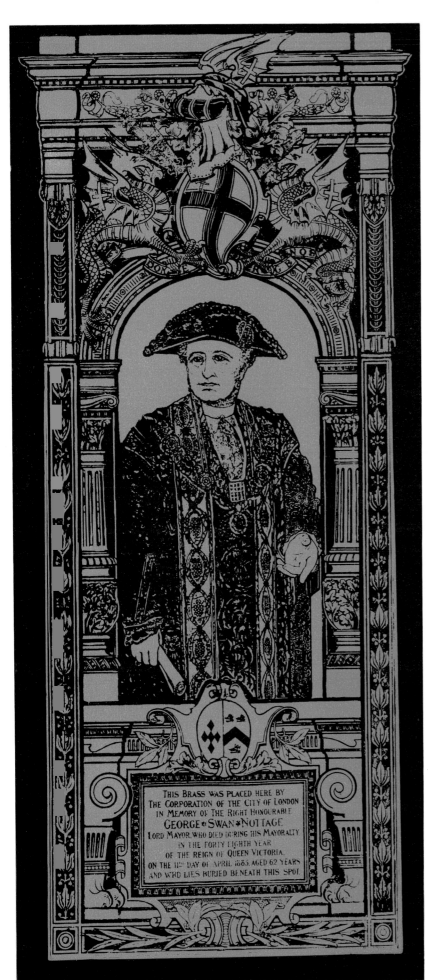

THIS BRASS WAS PLACED HERE BY
THE CORPORATION OF THE CITY OF LONDON
IN MEMORY OF THE RIGHT HONOURABLE
GEORGE ❖ SWAN ❖ NOTTAGE
LORD MAYOR, WHO DIED DURING HIS MAYORALTY
IN THE FORTY EIGHTH YEAR
OF THE REIGN OF QUEEN VICTORIA.
ON THE 11ᵀᴴ DAY OF APRIL 1885, AGED 62 YEARS
AND WHO LIES BURIED BENEATH THIS SPOT

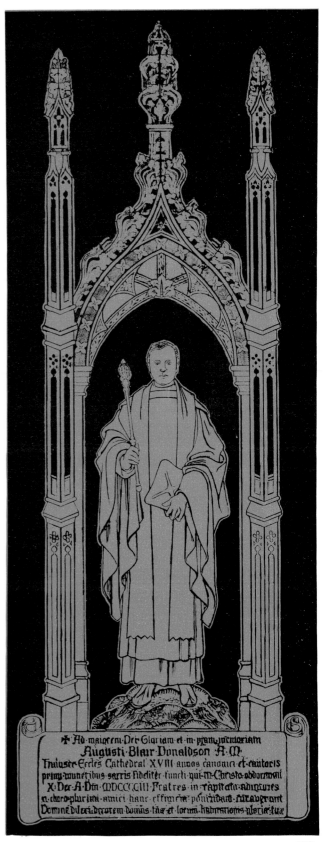

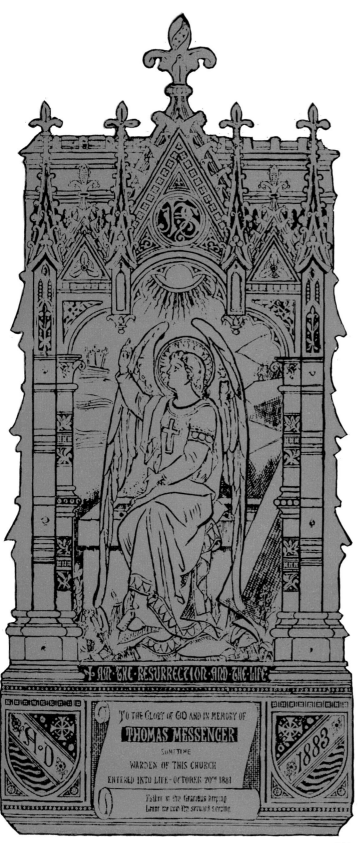

238. The Rt. Hon. George S. Nottage 1823–85, St Paul's Cathedral, London. The only Lord Mayor to be buried in St Paul's because he died in office. Designed by E. Onslow Ford R.A. Engraved by Hart, Son & Peard & Co. A difficult brass to rub because the incised lines are filled in with black composition. A typical Victorian conception of the best type of a portrait memorial. Size 90 × 35 in.

239. Canon Augustus Blair Donaldson 1903, Truro Cathedral, Cornwall. He was Canon Residentiary and first Precentor. This is a very derivative brass, the canopy especially so, where a form of perspective is introduced that does not obey any particular science. The effigy is simple, clean and of good workmanship. Size 60 in. deep.

240. Thomas Messenger 1881, St Anne's Protestant Episcopal Church, Brooklyn, New York. A very good period brass, to a one long time warden of the church. The scene shows an angel sitting on Christ's tomb near the three crosses of Calvary. At the bottom of the scroll, too small in the illustration to read clearly, is the following: *Father in thy gracious keeping Leave we now thy servant sleeping*. Though far removed from the original Gothic movement in monumental brasses, here we have an honest presentation of the Gothic revival in America. Engraved 1883. Size 84½ × 36 in.

240

241 and 242. Two brass fakes. These two brasses have been described in the Transactions of the Monumental Brass Society (Vol. x, Part ix, No. lxxxiii) as 'The Pseudo-Antique Brasses of St Chad's, Rochdale, Lancs.' There are two other 'fakes' not illustrated. They were placed there some time during the latter half of the nineteenth century. Fig. 241 shows James Deurden 1609 and fig. 242 Richard Deurden 1630. Those not illustrated are Oliver Deurden 1545 and Otiwell Deurden 1523. The Deurden family, who came up in the world as a result of the Industrial Revolution wished to establish themselves as ancient landowners and entitled to arms (alas no), erected these monuments, as well as others and altered the old Chantry Chapel extensively and replaced old glass windows with new ones to the memory of various Deurdens.

The Rev. Austin Chadwick f.s.c., m.a., to whom I am indebted for my short notes, writes at length in the above-named Transactions.

An interesting article on Counterfeit Brasses appears in The Transactions of the Monumental Brass Society Vol. ix, Part ix, No. lxxix. It is illustrated by a brass Griele van Ruwescuere, Bruges, and its counterfeit Griele Aga Stevens.

241

242